CARS

Tin Toy Dreams

By Teruhisa Kitahara

Chronicle Books · San Francisco

First published in the United States
1985 by Chronicle Books.

First published in Japan by Shinko
Music Publishing Co., Ltd. Printed
in Japan by Dai Nippon Printing
Co., Ltd., Tokyo.

**Library of Congress Cataloging
in Publication Data**

Kitahara, Teruhisa.
Cars: tin toys.

Rev. ed. of: Tin toy cars. 1984.
1. Automobiles–Models–Catalogs.
2. Tin toys–Japan–Catalogs.
3. Kitahara, Teruhisa–Art
collections–Catalogs. 4. Tin
toys–Private collections–Japan–
Catalogs. I. Kitahara, Teruhisa.
Tin toy cars. II. Title.
TL237.K53 1985 629.2'21
84-23301 ISBN 0-87701-349-7

Chronicle Books
One Hallidie Plaza
San Francisco, CA 94102

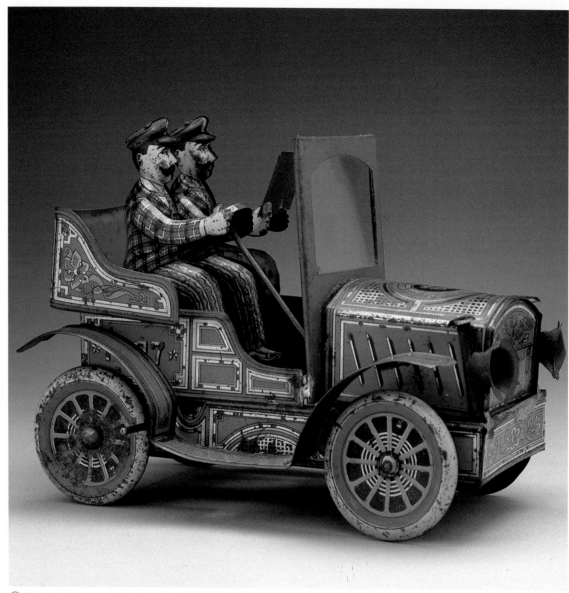

①1910'S／CLASSIC CAR／Y. SUZUKI／175×100×120
NUMBER／DECADE／NAME／MAKER／SIZE: depth×width×height(mm)

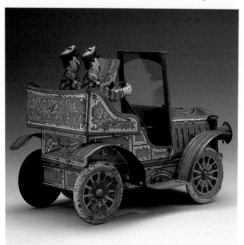

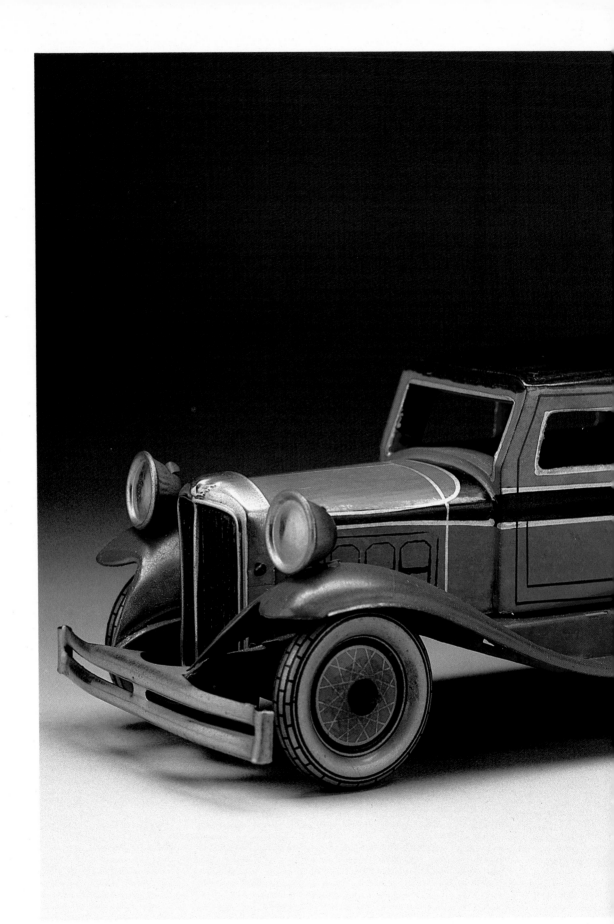

②1930'S／CHILDREN BUS／TOMIYAMA／235×115×90

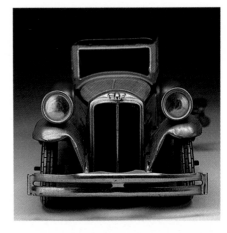

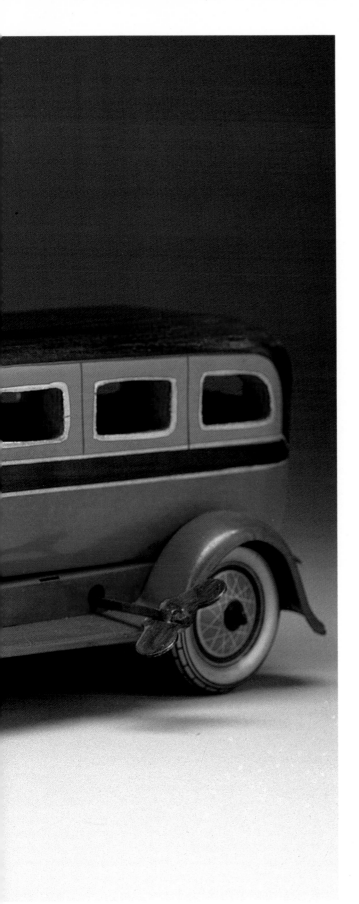

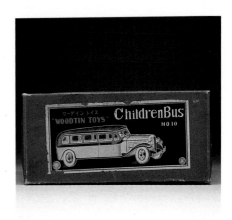

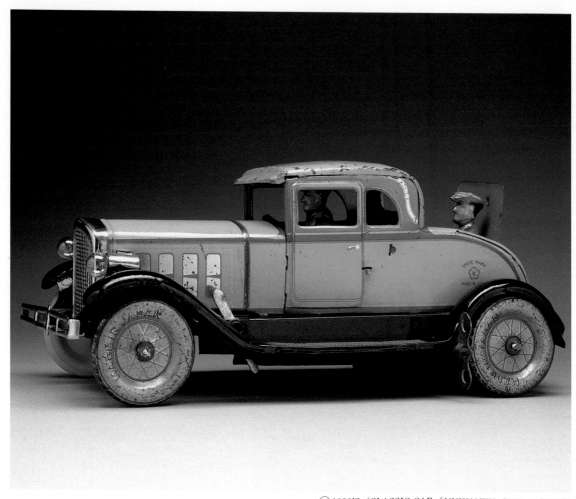

③ 1930'S／CLASSIC CAR／UNKNOWN／260×110×105
NUMBER／DECADE／NAME／MAKER／SIZE: depth × width × height (mm)

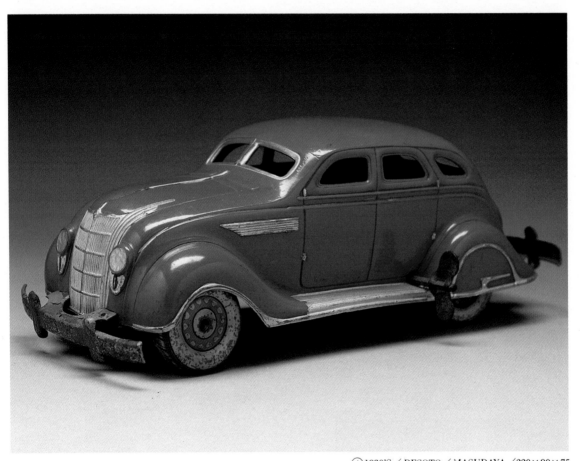

④1930'S／DESOTO／MASUDAYA／220×90×75

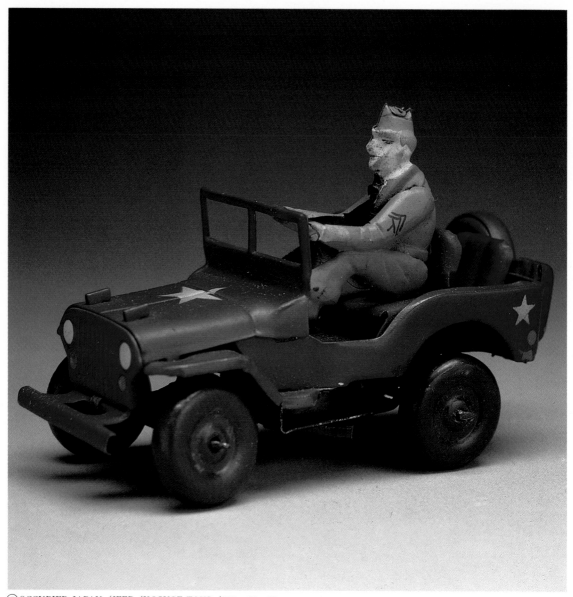

⑤OCCUPIED JAPAN／JEEP／KOSUGE TOYS／105×45×68

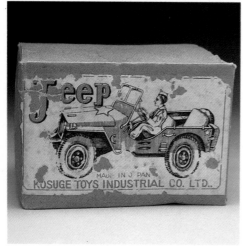

CASE ATTACHED

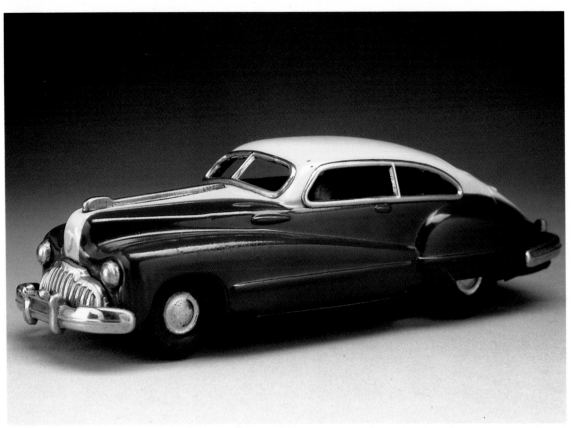

⑥OCCUPIED JAPAN／1946 BUICK ROADMASTER／TAICO／160×60×45

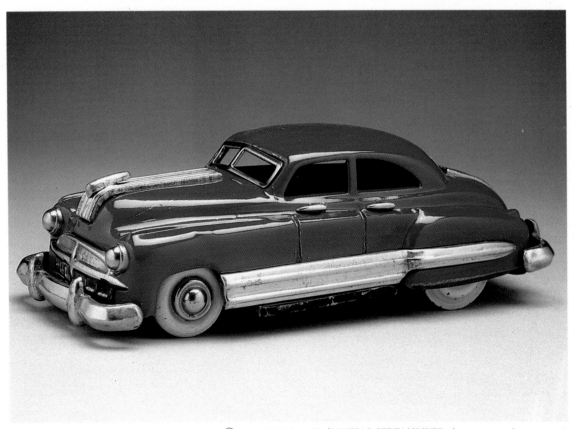

⑦OCCUPIED JAPAN／PONTIAC STREAMLINER／UNKNOWN／155×65×50

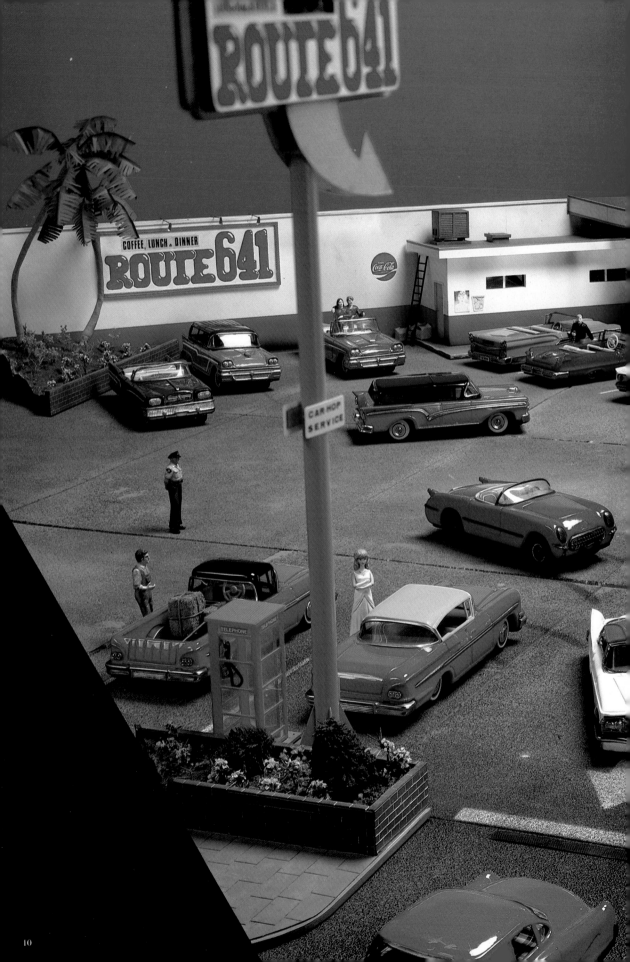

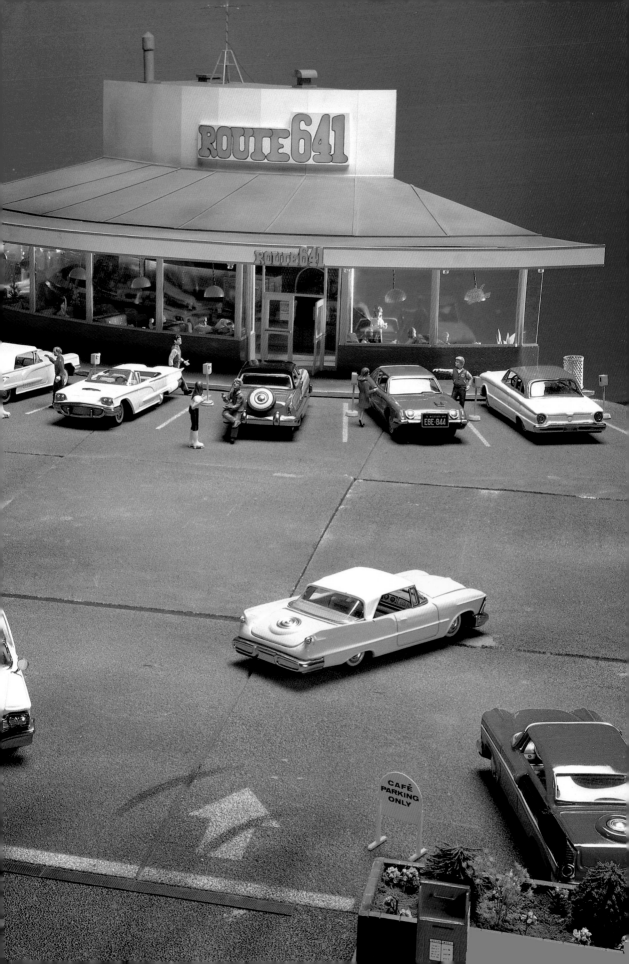

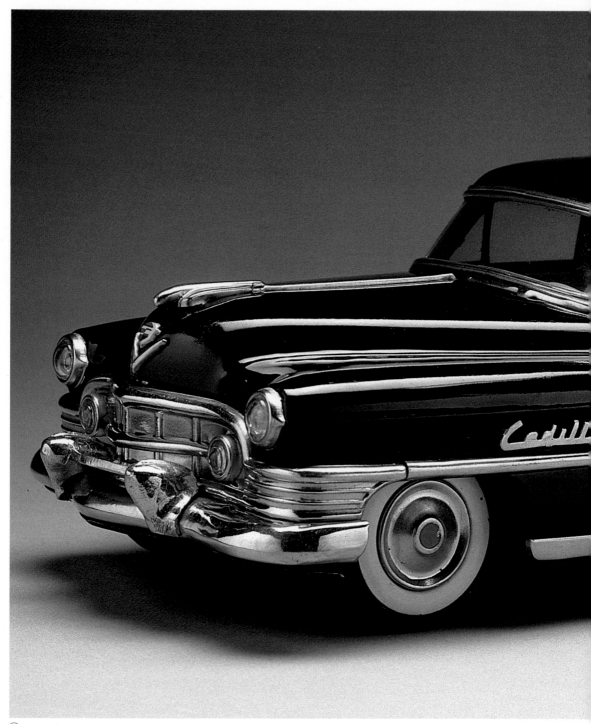

⑧1950'S／CADILLAC／MARUSAN／315×125×95

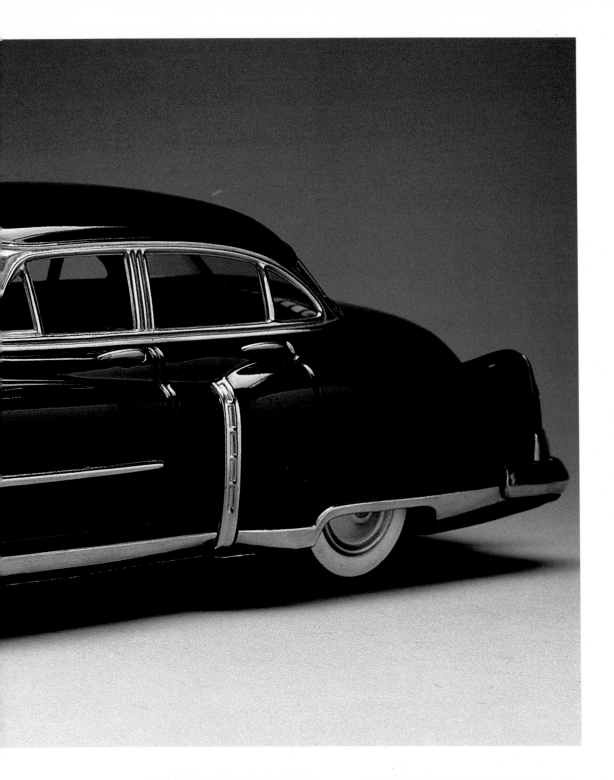

CASE ATTACHED

13

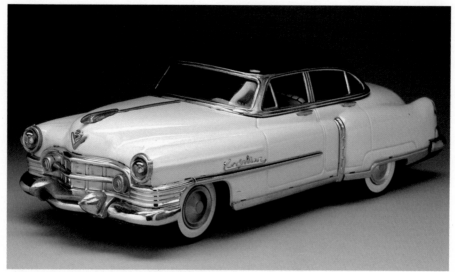

⑨1950'S／CADILLAC／MARUSAN／315×125×95

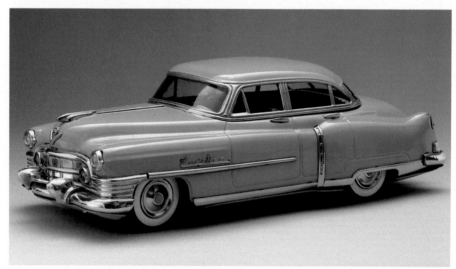

⑩1950'S／CADILLAC／MARUSAN／315×125×95

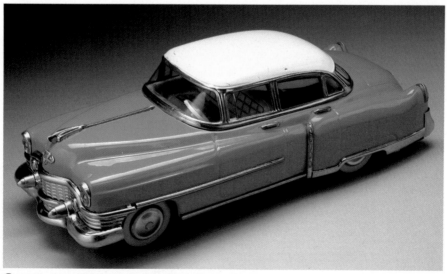

⑪1950'S／1954 CADILLAC 60／JOUSTRA／310×125×95

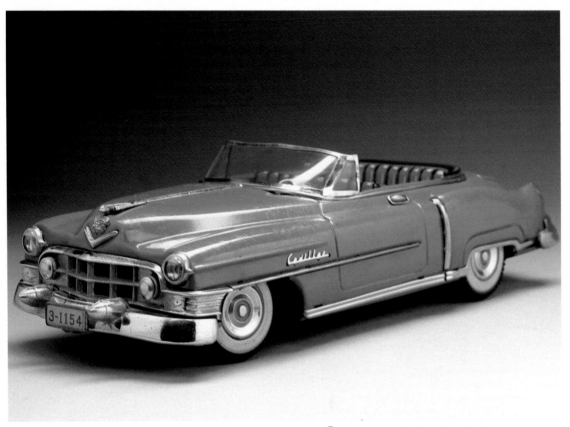

⑫1950'S／1952 CADILLAC 62／ALPS／290×110×75

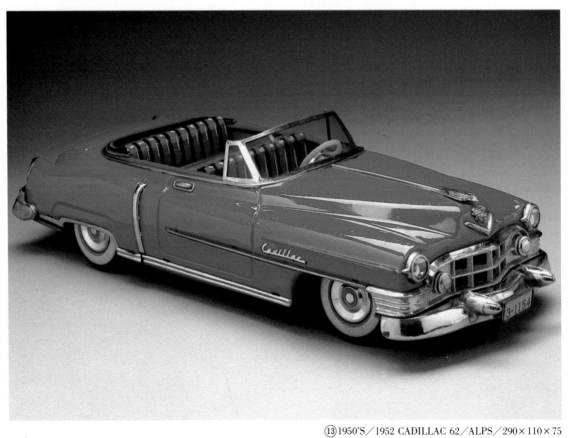

⑬1950'S／1952 CADILLAC 62／ALPS／290×110×75

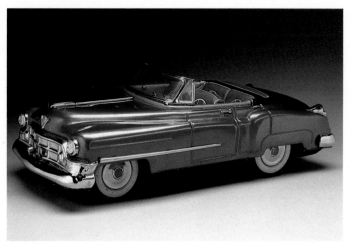

⑭1950'S／1954 CADILLAC／NOMURA／340×150×105

CASE ATTACHED

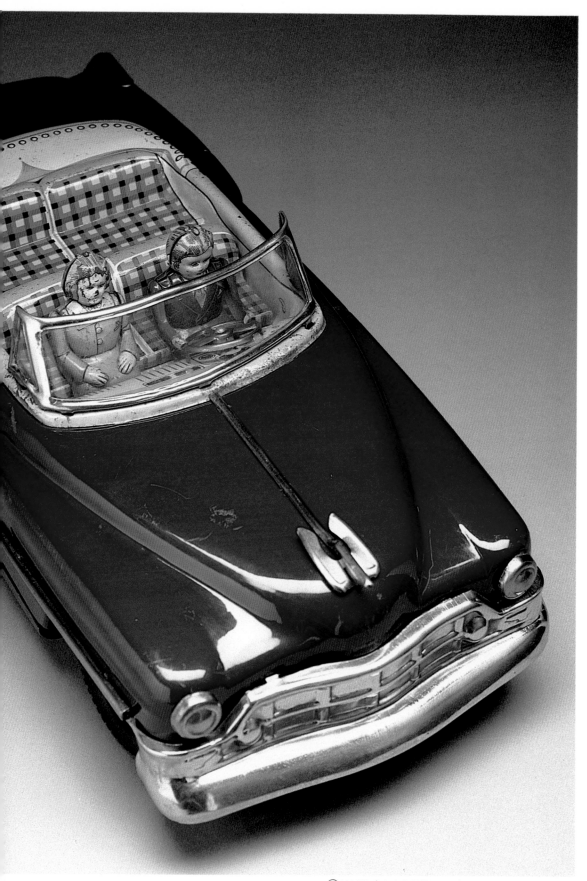

⑮1950'S／1953 CADILLAC／NOMURA／340×150×105

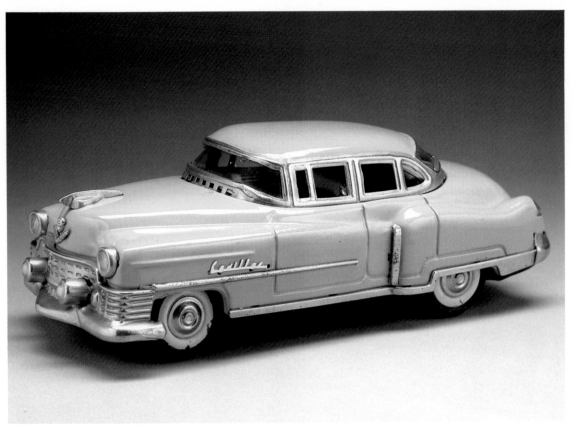

⑯1950'S／CADILLAC 60／UNKNOWN／235×95×80

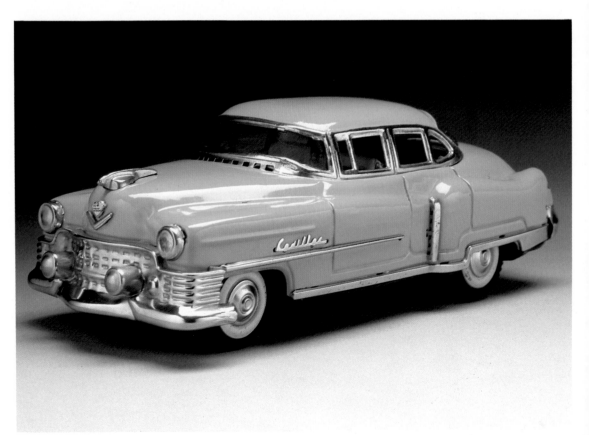

⑰1950'S／CADILLAC 60／UNKNOWN／235×95×80

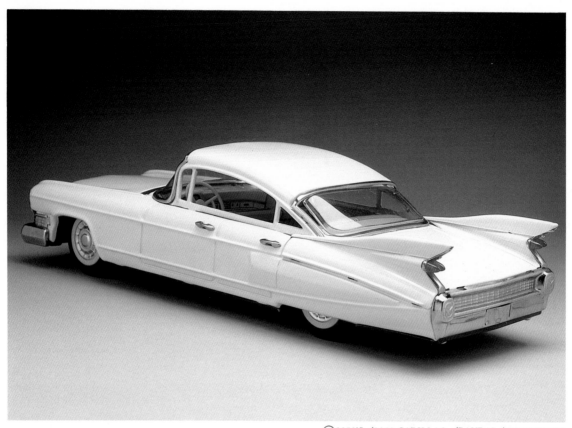

⑱1950'S／1959 CADILLAC／BANDAI／280×105×75

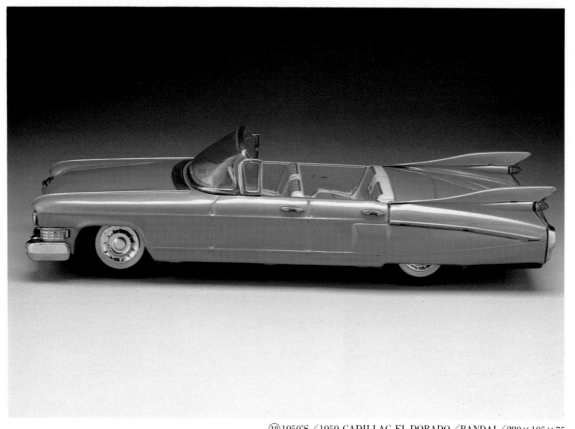

⑲1950'S／1959 CADILLAC EL-DORADO／BANDAI／280×105×75

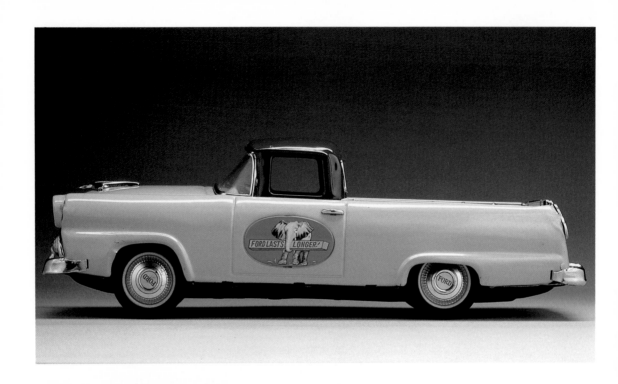

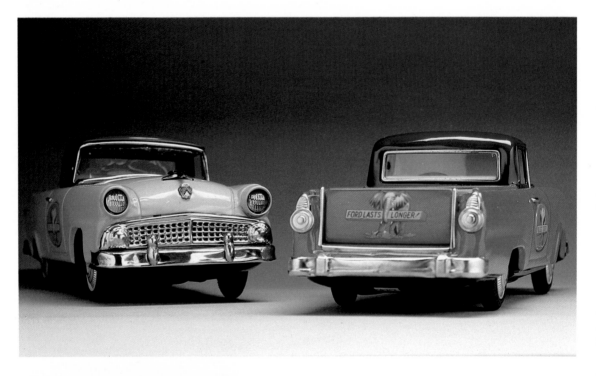

⑳㉑ 1950'S／1957 FORD PICK-UP／BANDAI／305×110×95
CASE ATTACHED

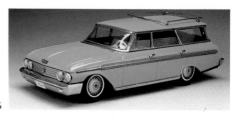

㉒1960'S／FORD RANCH WAGON／ASAHI／310×115×95

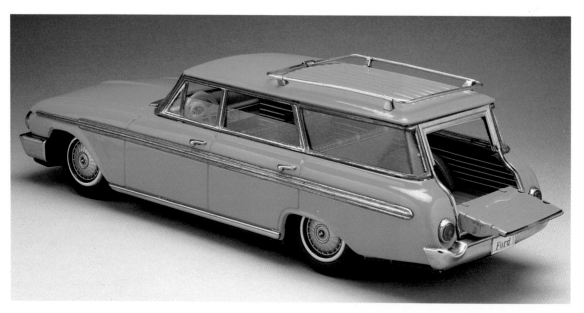

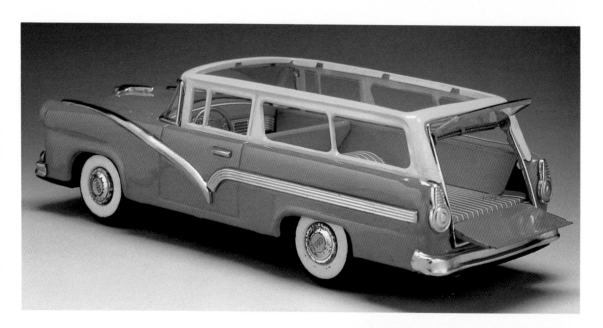

㉓1950'S／1956 FORD WAGON／NOMURA／265×100×85

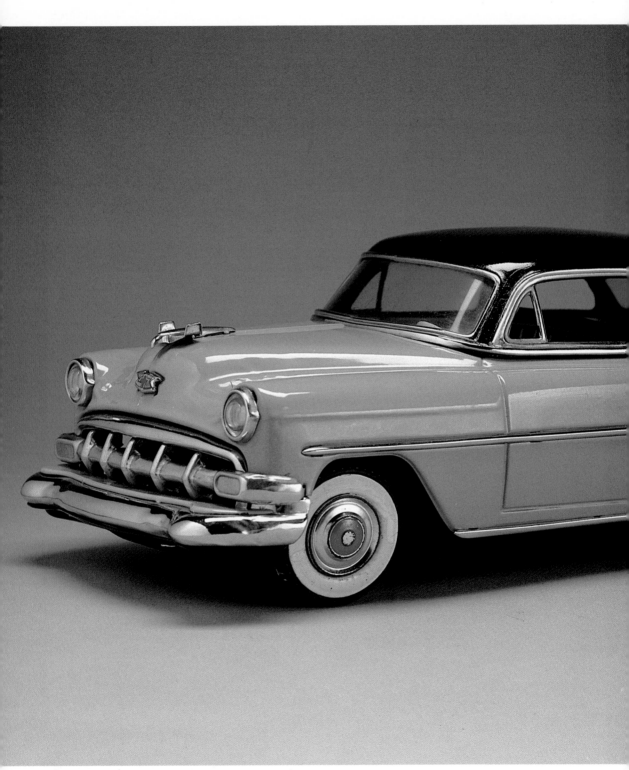

㉔1950'S／1954 CHEVROLET BEL-AIR／MARUSAN／280×125×95

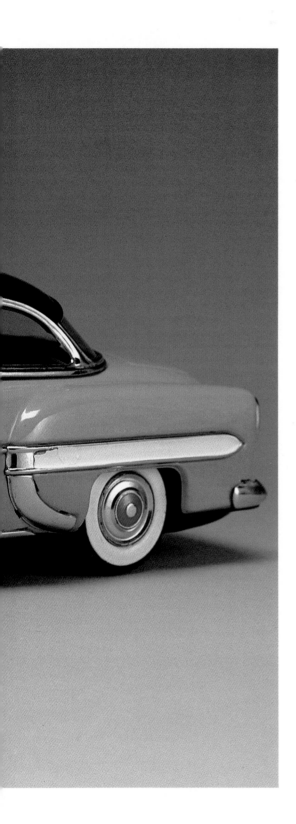

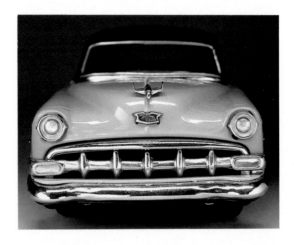

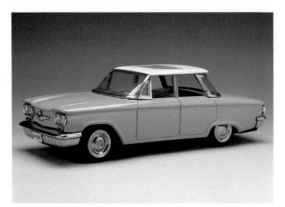

㉕1960'S／1960 CHEVROLET CORVAIR／ICHIKO
／235×90×75

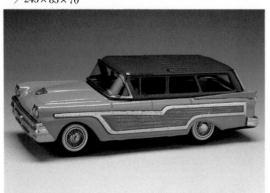

㉖1950'S／1956 CHEVROLET STATION WAGON／BANDAI
／245×85×70

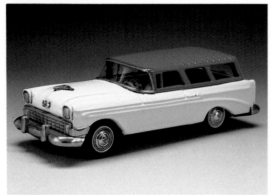

㉗1950'S／1958 FORD COUNTRY SQUIRE STATION
WAGON／BANDAI／195×80×60

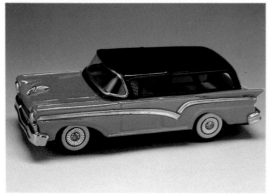

㉘1950'S／1957 FORD STATION WAGON／NOMURA
／190×80×60

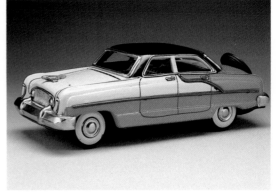

㉙1950'S／1956 NASH AMBASSADOR／SANKEI GANGU
／205×85×65

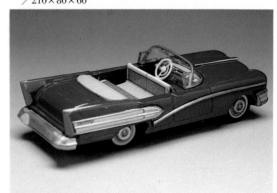

㉚1950'S／1958 CHEVROLET PICK-UP／BANDAI
／210×80×60

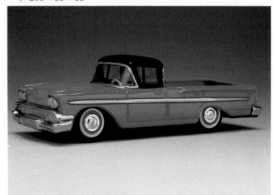

㉛1950'S／1958 BUICK CENTURY／BANDAI／210×80×60

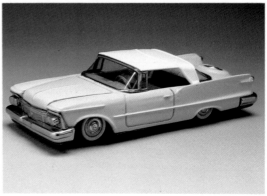

㉜1950'S／1958 CHRYSLER IMPERIAL／BANDAI
／210×80×55

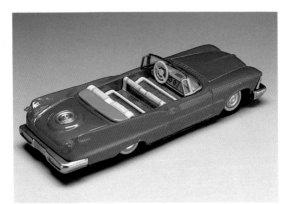

㉝1950'S／1958 CHRYSLER IMPERIAL／BANDAI
／210×80×50

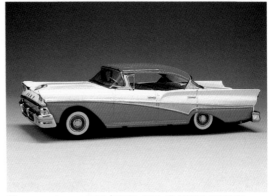

㊲1950'S／1958 FORD FAIRLANE／SANKEI GANGU
／245×95×70

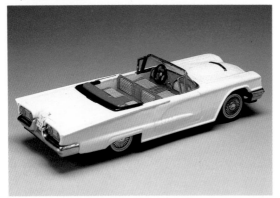

㉞1950'S／1958 FORD THUNDERBIRD／BANDAI
／210×75×55

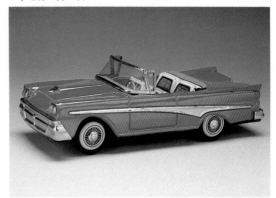

㊳1950'S／1958 FORD FAIRLANE／BANDAI／200×75×60

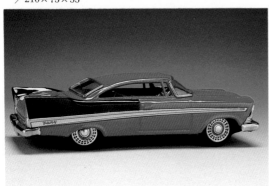

㉟1950'S／1958 PLYMOUTH FURY／BANDAI
／210×80×60

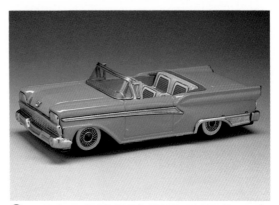

㊴1950'S／1959 FORD FAIRLANE SKYLINER／BANSEI
GANGU／200×80×55

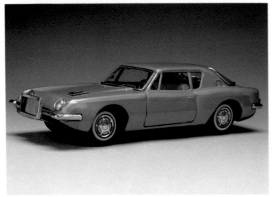

㊱1960'S／1964 STUDEBAKER AVANTI／BANDAI
／210×75×60

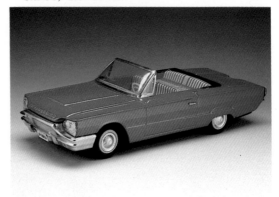

㊵1960'S／1964 FORD THUNDERBIRD／ASAHI
／310×110×85

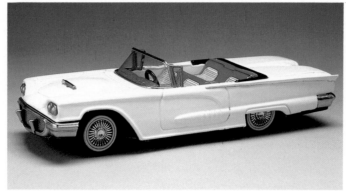

㊷FORD THUNDERBIRD／BANDAI

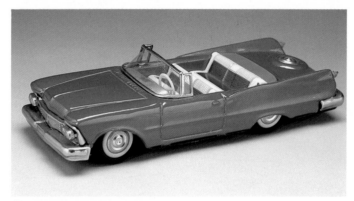

㊸CHRYSLER IMPERIAL／BANDAI

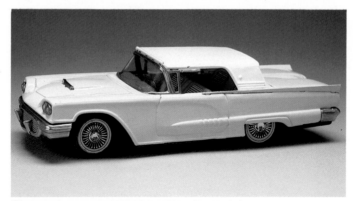

㊹1950'S／1958 FORD THUNDERBIRD／BANDAI／210×75×60

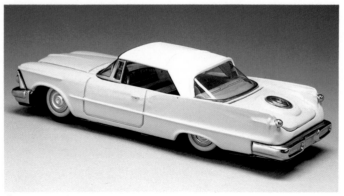

㊺CHRYSLER IMPERIAL／BANDAI

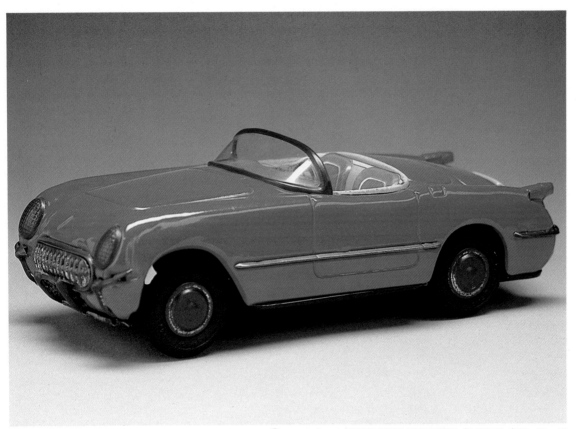

㊺1950'S／1953 CHEVROLET CORVETTE／BANDAI／180×75×60

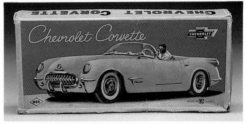

CASE ATTACHED

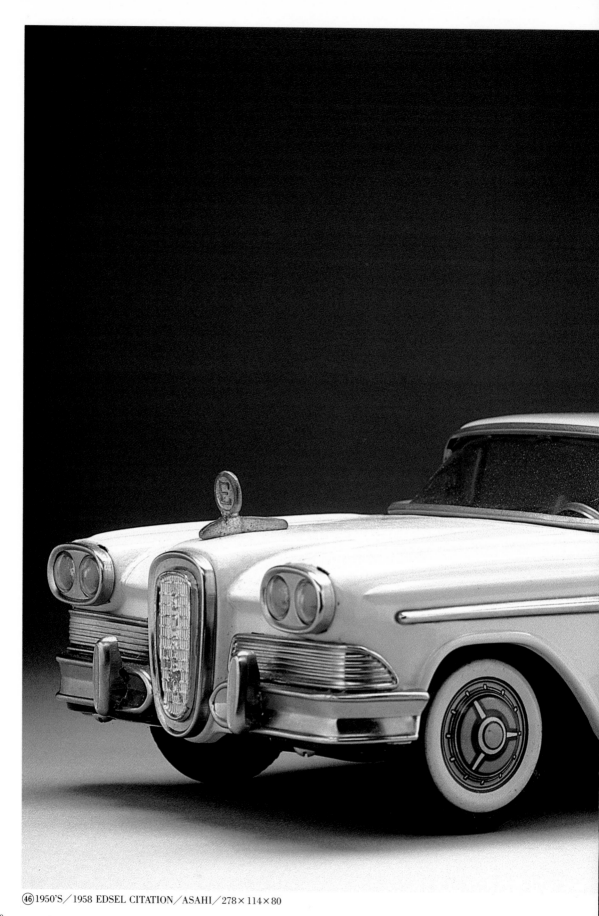

㊻ 1950'S／1958 EDSEL CITATION／ASAHI／278×114×80

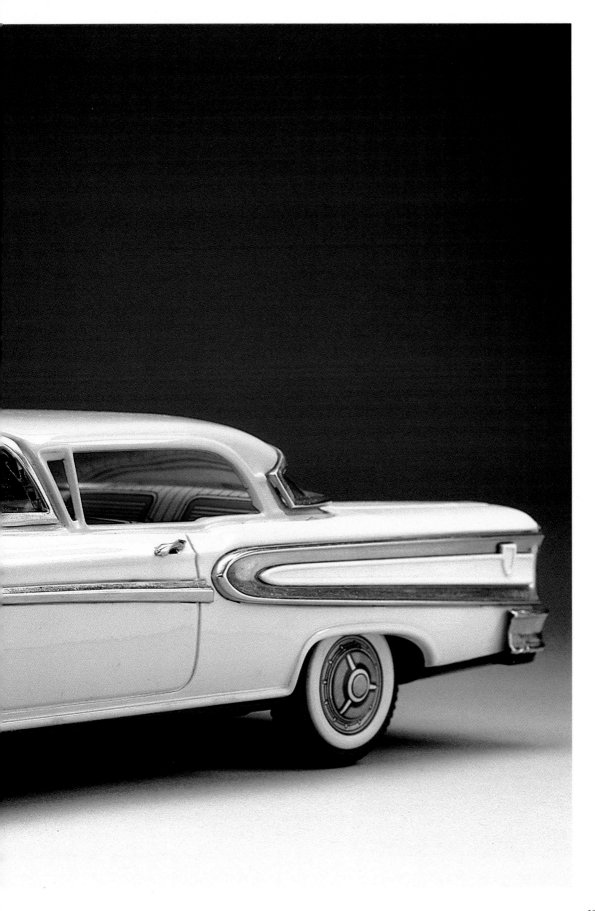

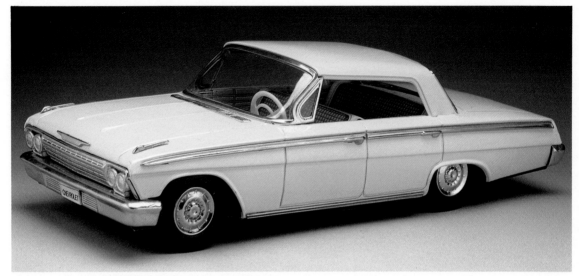

㊼1960'S／1963 CHEVROLET IMPALA／ASAHI／300×110×85

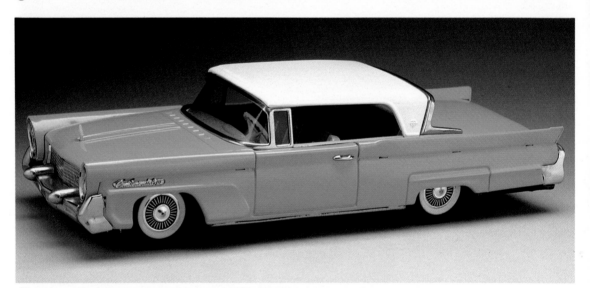

㊽1950'S／1958 LINCOLN CONTINENTAL MARK III／BANDAI／295×105×75

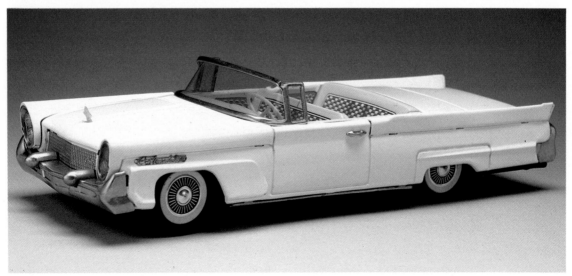

㊾1950'S／1958 LINCOLN CONTINENTAL MARK III／BANDAI／295×105×75

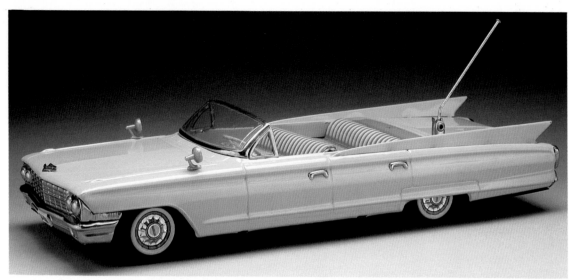

㊿ 1960'S／1962 CADILLAC／YONEZAWA／355×125×75

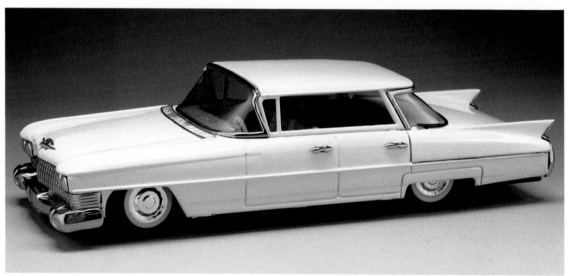

�51 1960'S／1960 CADILLAC EL-DORADO／BANDAI／290×100×75

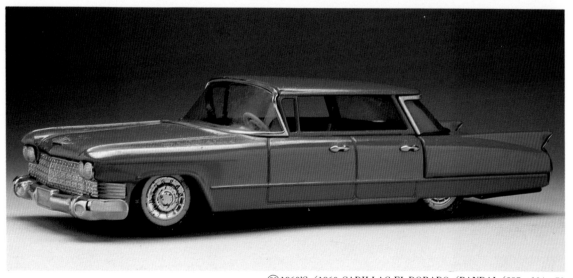

�52 1960'S／1960 CADILLAC EL-DORADO／BANDAI／287×104×70

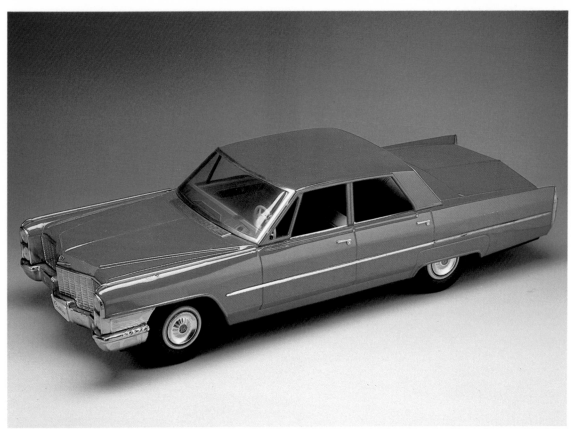

㊼1960'S／CADILLAC／NOMURA／645×223×162

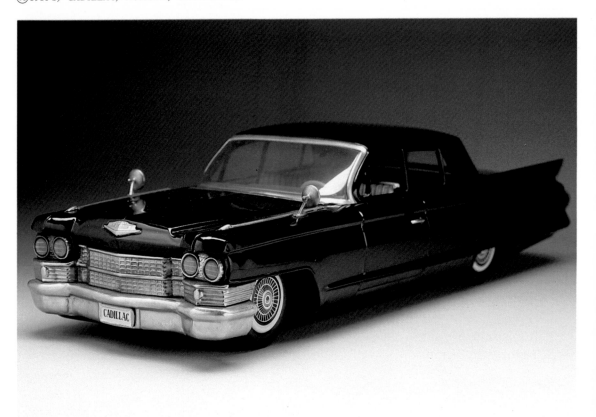

㊿1960'S／1961 CADILLAC FLEETWOOD／BANDAI／430×160×110

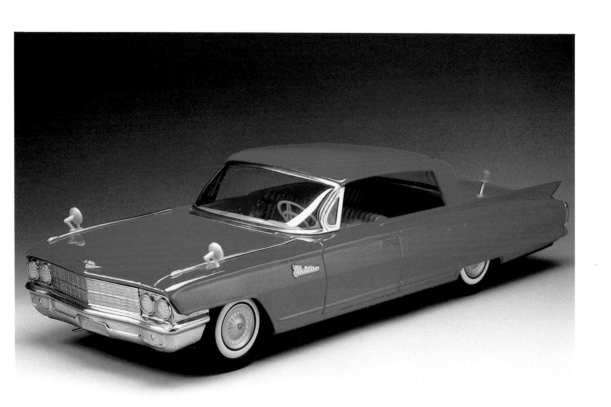

⑤⑤ 1960'S／CADILLAC／ICHIKO／500×168×120

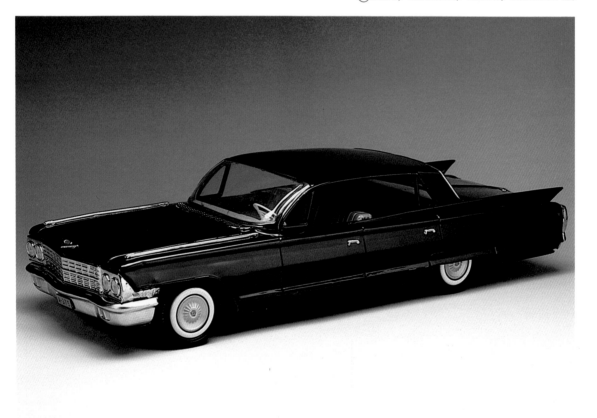

⑤⑥ 1960'S／1960 CADILLAC EL-DORADO／YONEZAWA／460×170×105

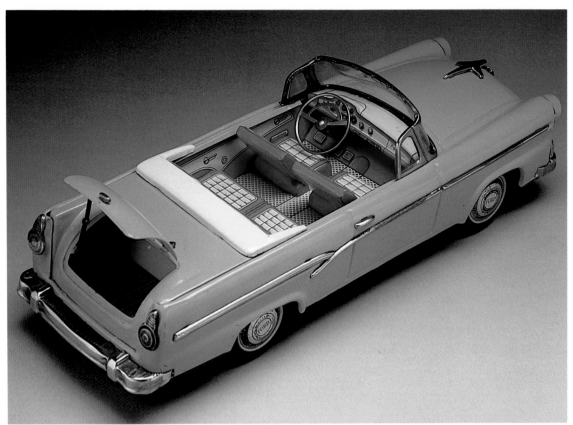

㊄1950'S／1956 FORD FAIRLANE／BANDAI／305×114×85

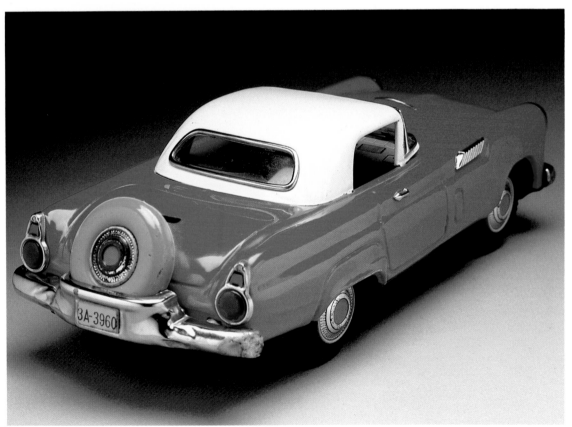

㊅1950'S／1956 FORD THUNDERBIRD／UNKNOWN／285×110×80

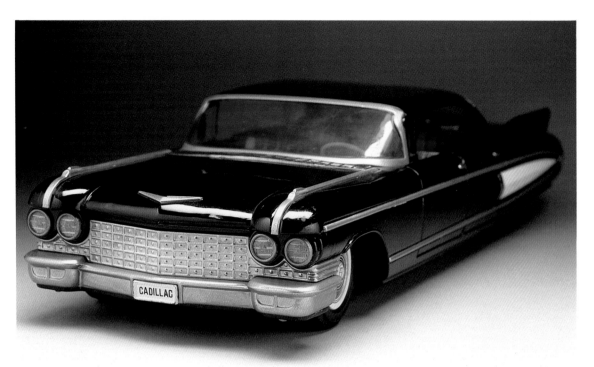

�59 1960'S／CADILLAC／YONEZAWA／550×195×123

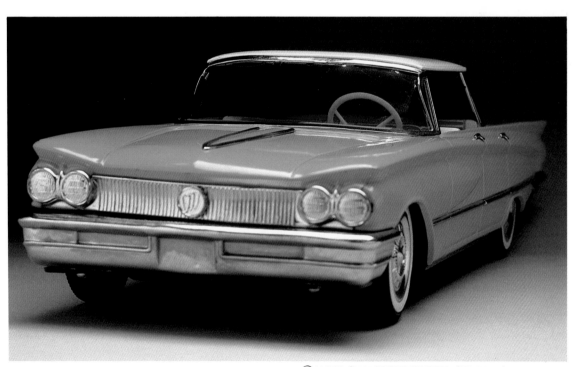

�60 1960'S／1960 BUICK INVICTA／ICHIKO／450×170×110

CASE ATTACHED

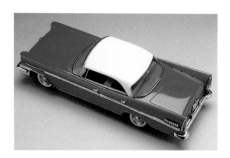

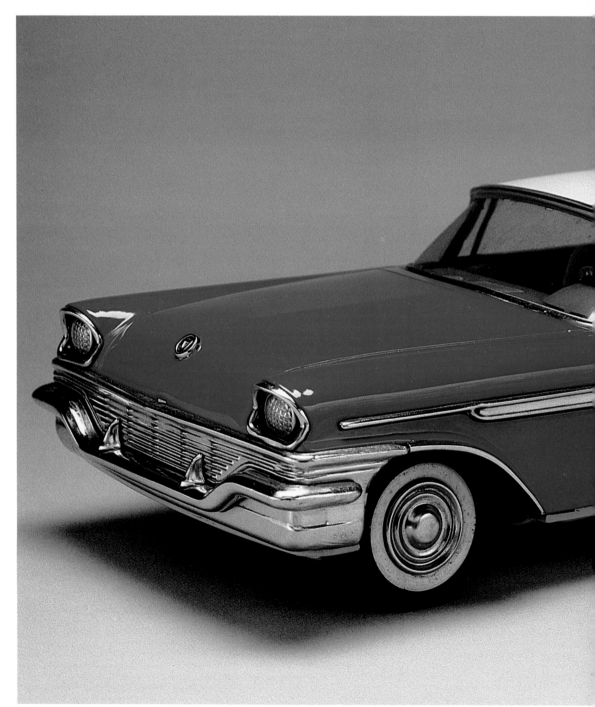

⑥1950'S／1956 CHRYSLER NEWYORKER／ALPS／350×140×95

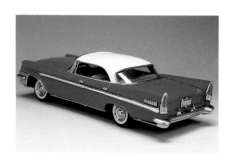

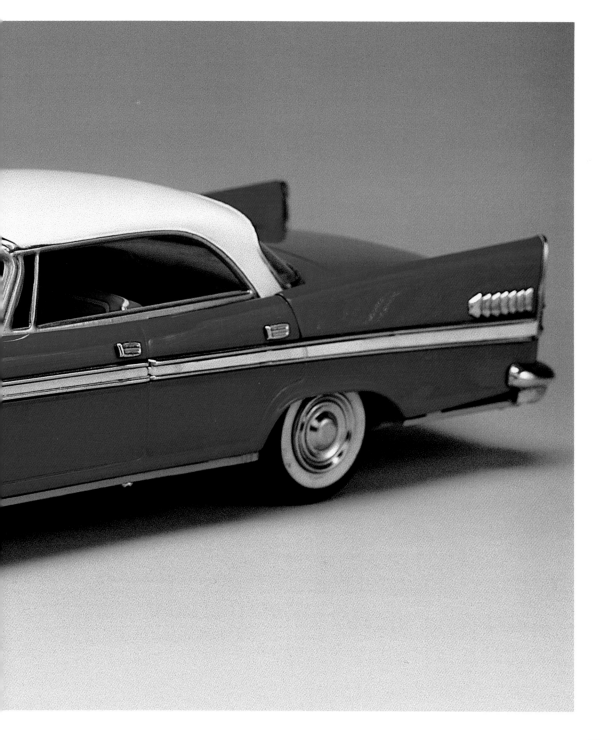

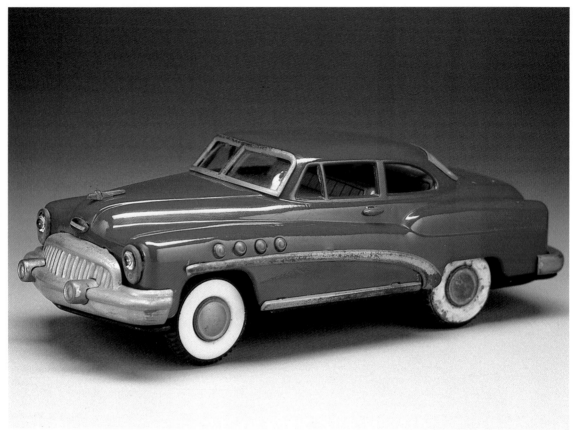

⑥②1950'S／1953 BUICK ROADMASTER CONSTRUCTION KIT／MARUSAN／85×80×60

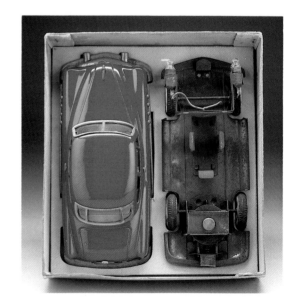

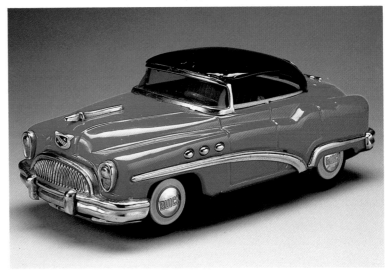

㉓1950'S／BUICK／UNKNOWN／270×125×100

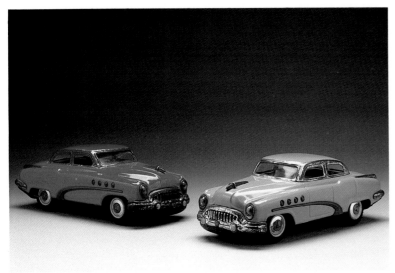

㉔㉕1950'S／GOOD OLD BUICKS／MARUSAN／210×90×65

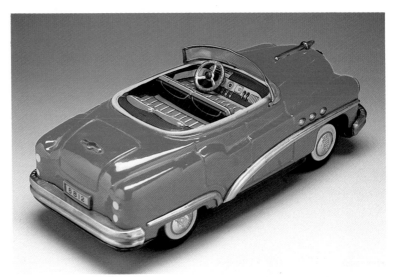

㉖1950'S／BUICK CONVERTIBLE／UNKNOWN／285×120×95

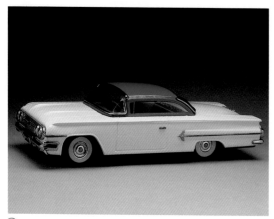

㊿1960'S／1960 CHEVROLET BEL-AIR／MARUSAN
／295×110×80

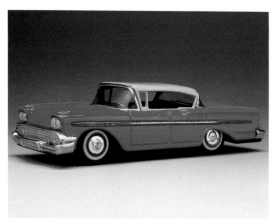

㊽1950'S／1958 CHEVROLET BEL-AIR／BANDAI
／210×80×60

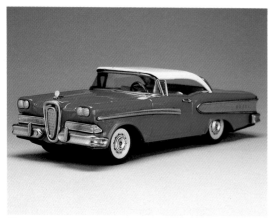

㊾1950'S／1958 EDSEL CORSAIR／UNKNOWN
／270×105×80

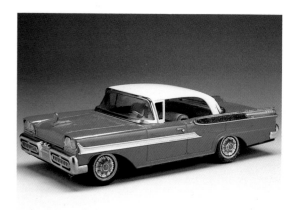

�70 1950'S／1958 MERCURY PARK-LANE／YONEZAWA
／295×125×85

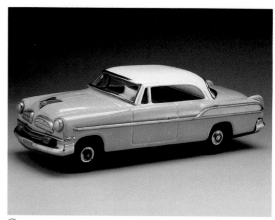

⑦ 1950'S／1955 CHRYSLER／YONEZAWA／220×85×70

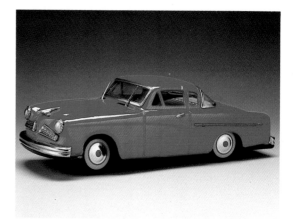

⑦ 1950'S／1954 STUDEBAKER／YOSHIYA／220×90×70

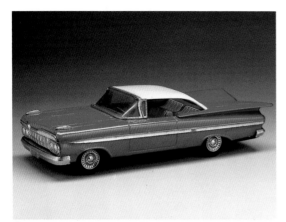

⑦③ 1950'S／1959 CHEVROLET IMPALA／UNKNOWN
／255×95×67

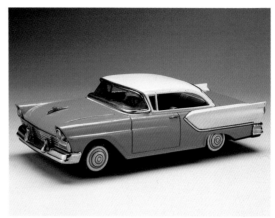

⑦⑥ 1950'S／1957 FORD FAIRLANE／ICHIKO／250×110×80

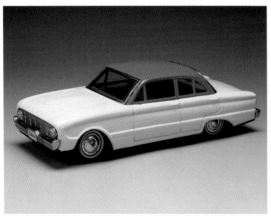

⑦④ 1960'S／FORD FALCON／BANDAI／210×80×60

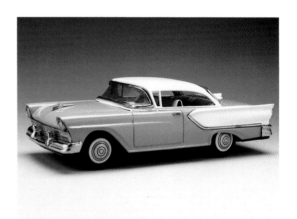

⑦⑦ 1950'S／1957 FORD FAIRLANE／ICHIKO／250×110×80

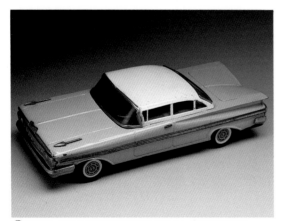

⑦⑤ 1950'S／1959 CHEVROLET IMPALA／UNKNOWN
／315×125×80

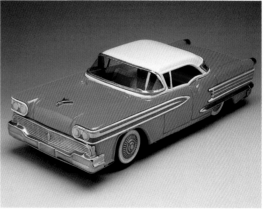

⑦⑧ 1950'S／1958 OLDSMOBILE SUPER 88／ASAHI
／325×130×95

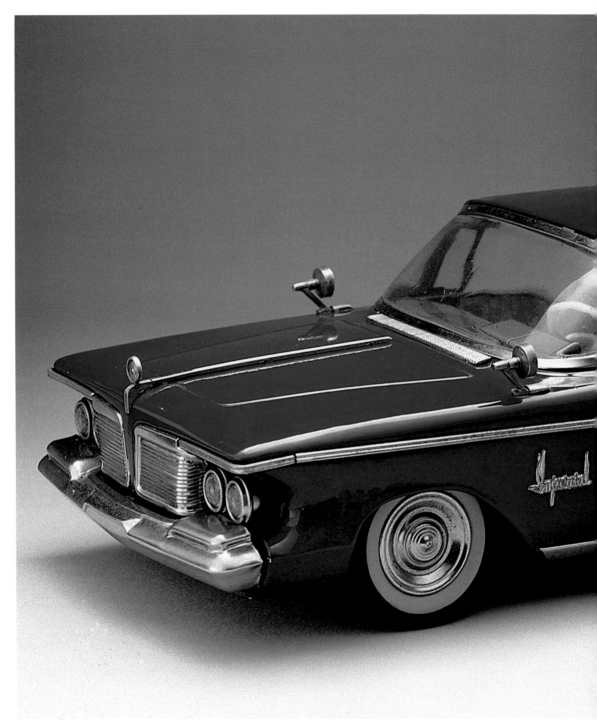

㉟1960'S／1962 CHRYSLER IMPERIAL LE-BARON／ASAHI／390×150×100

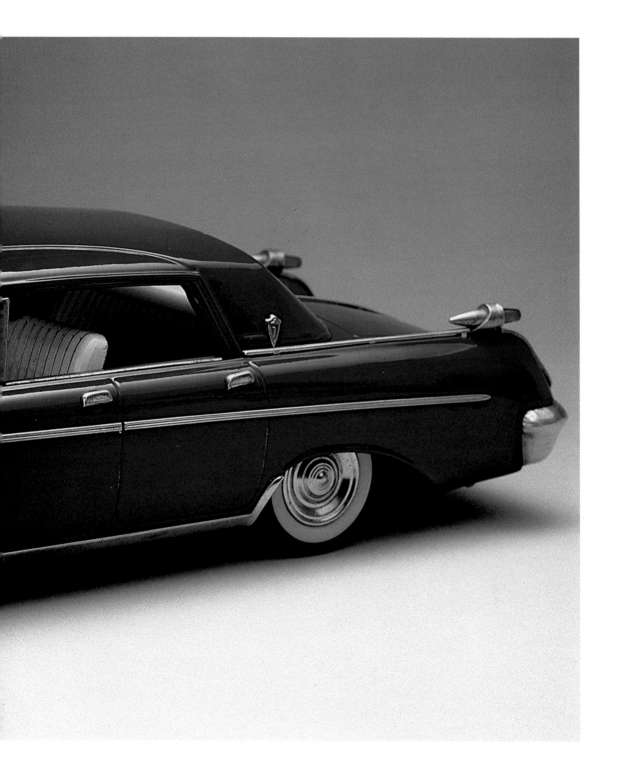

CASE ATTACHED

43

CASE ATTACHED
⑧⓪ 1950'S／1954 LINCOLN／YONEZAWA／325×125×100

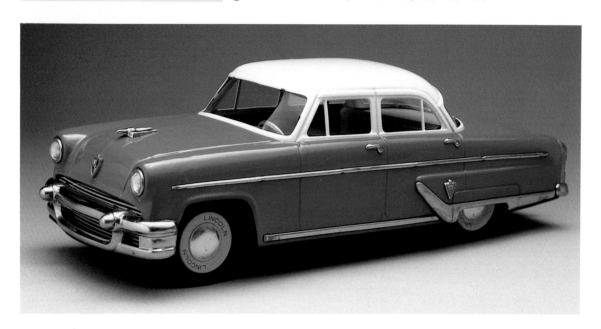

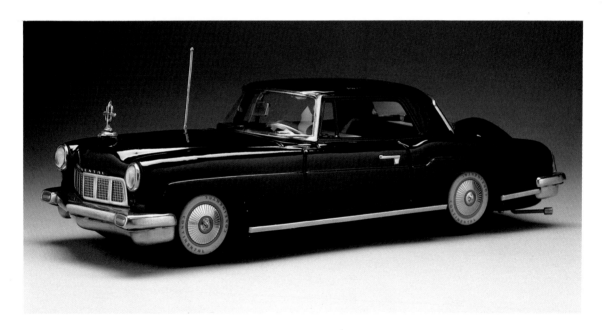

⑧① 1950'S／1957 LINCOLN CONTINENTAL MARK II／LINE MAR
／290×105×80
CASE ATTACHED

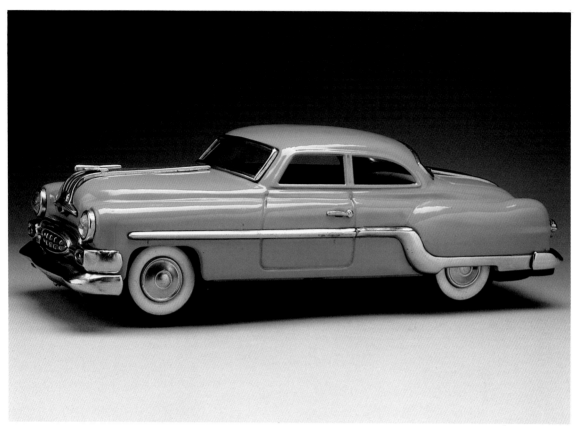

㉒1950'S／1954 PONTIAC STAR-CHIEF／ASAHI／250×105×80

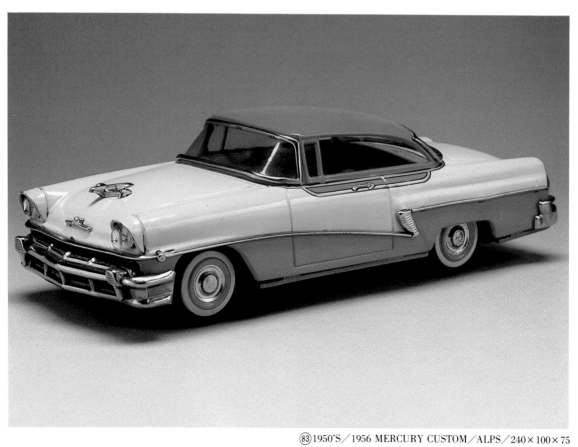

㉓1950'S／1956 MERCURY CUSTOM／ALPS／240×100×75

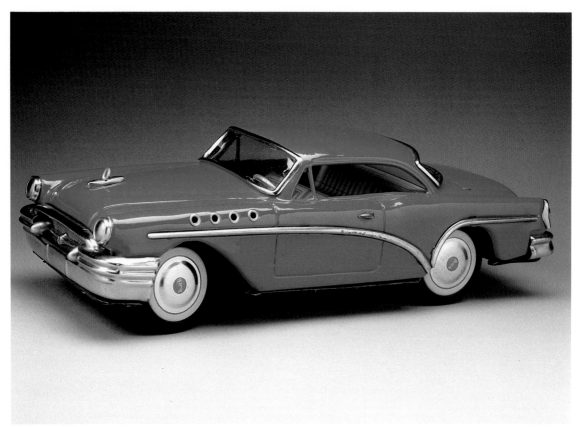

㉘ 1950'S／1955 BUICK ROADMASTER／YOSHIYA／265×110×80

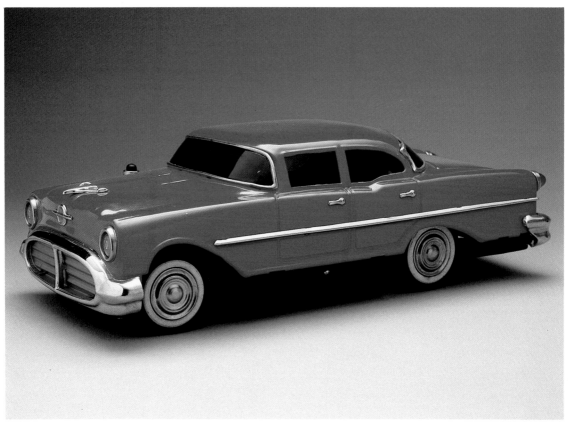

㉙ 1950'S／1956 OLDSMOBILE SUPER 88／MASUDAYA／350×160×105

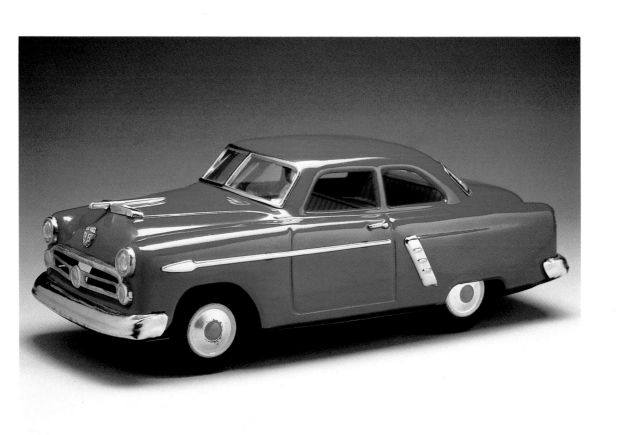

86 1950'S／AMERICAN CAR／MARUSAN／210×90×65

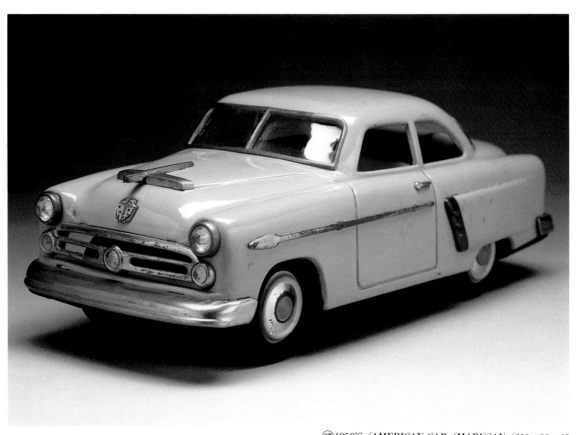

87 1950'S／AMERICAN CAR／MARUSAN／210×90×65

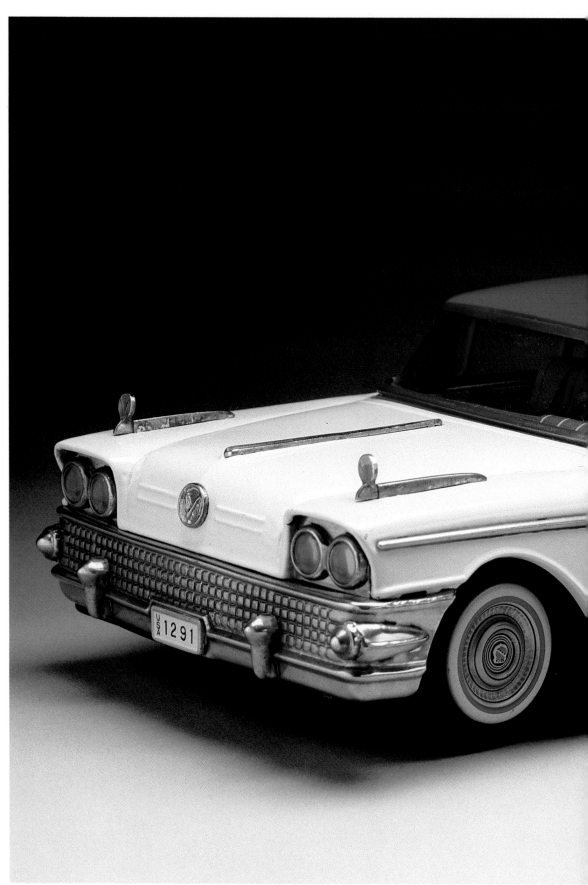

⑧⑧ 1950'S／1958 BUICK CENTURY／YONEZAWA／295×125×85

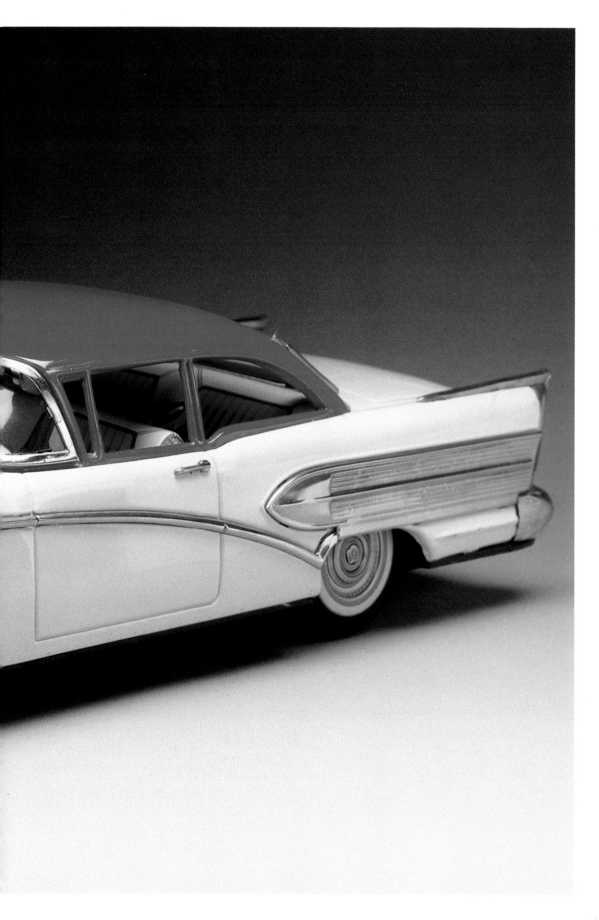

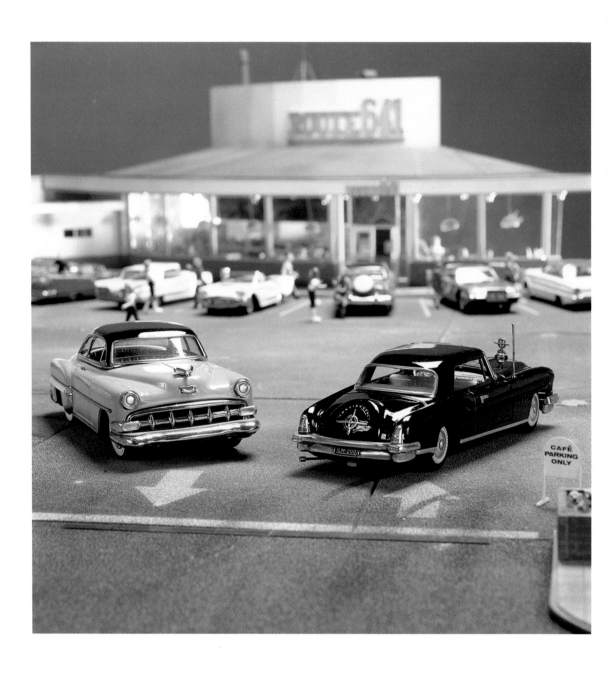

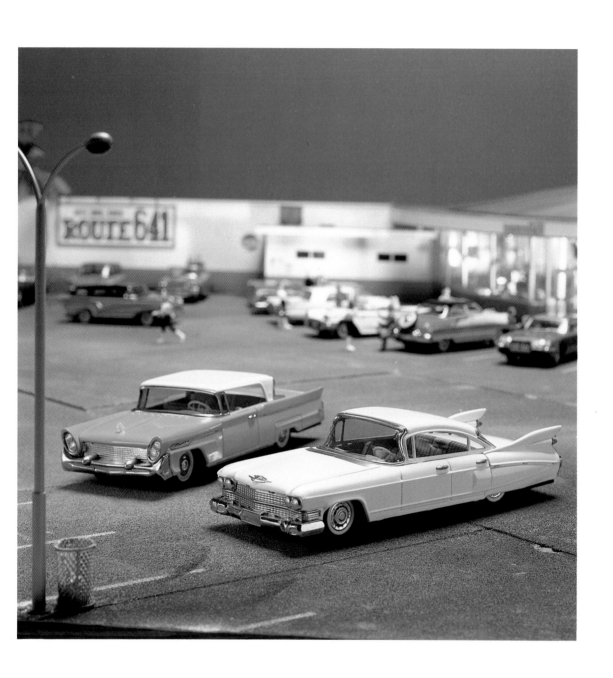

⑧⑨ 1950'S／TRAILER TRUCK／MARUSAN／450×145×180

⑨⑩ 1960'S／GMC TRUCK／YONEZAWA／400×140×130

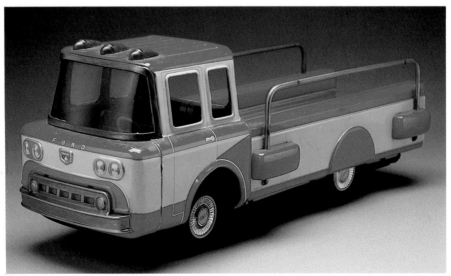

⑨① 1960'S／FORD DIAMOND TRUCK／YONEZAWA／380×140×140

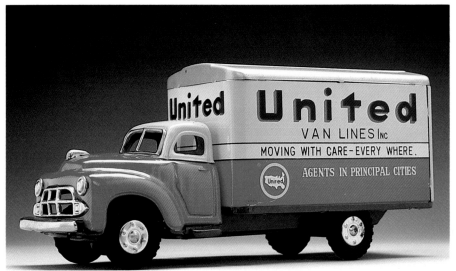

⑨2 1950'S／TRUCK／UNKNOWN／275×95×120

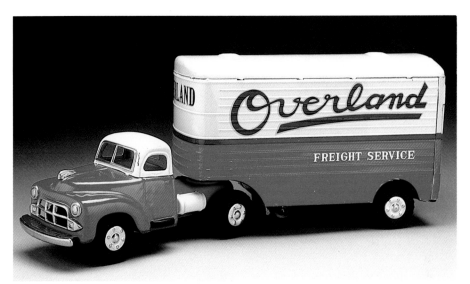

⑨3 1950'S／TRAILER TRUCK／UNKNOWN／365×90×140

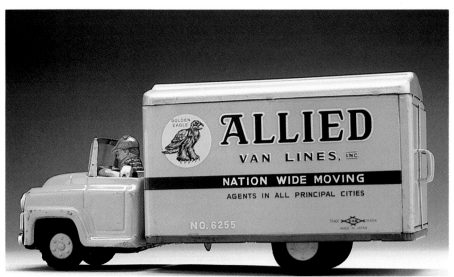

⑨4 1950'S／TRUCK／DAISHIN KOGYO／250×90×110

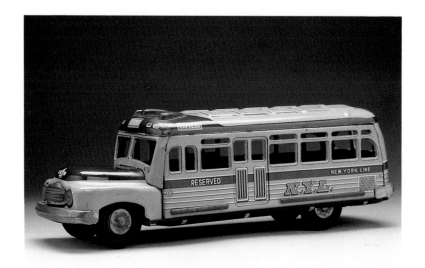

⑨⑤1950'S／OMNIBUS／NAITO SHOTEN／298×92×82

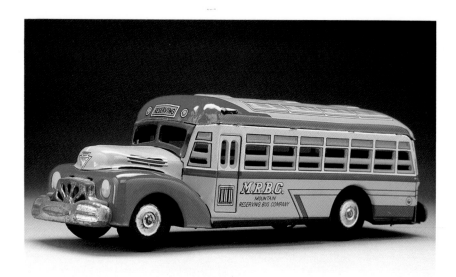

⑨⑥1950'S／OMNIBUS／UNKNOWN／244×70×75

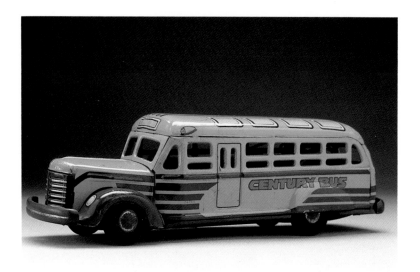

⑨⑦1950'S／OMNIBUS／NIHON BOEKI／218×60×62

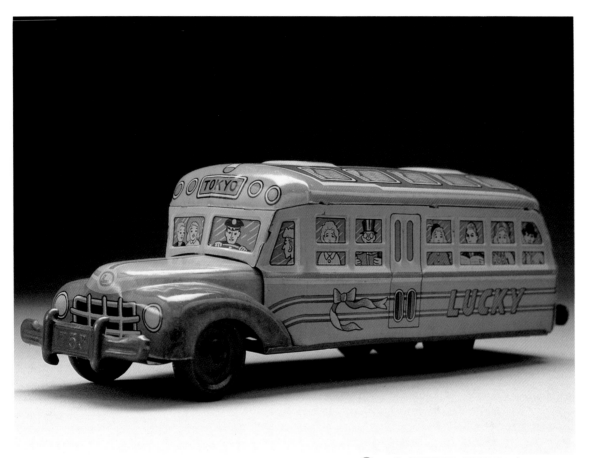

98 1950'S／OMNIBUS／NOMURA／210×66×70

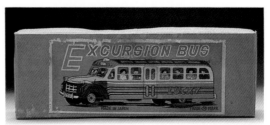

CASE ATTACHED

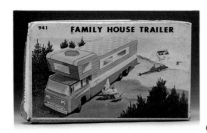

CASE ATTACHED

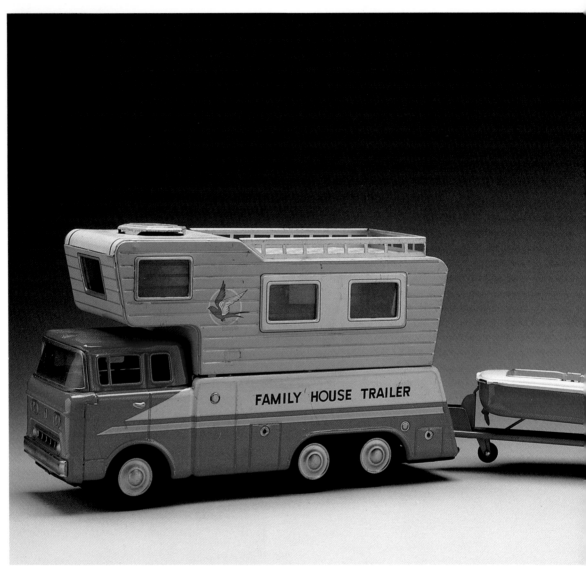

⑨⑨1960'S／FAMILY HOUSE TRAILER／BANDAI／315×95×180

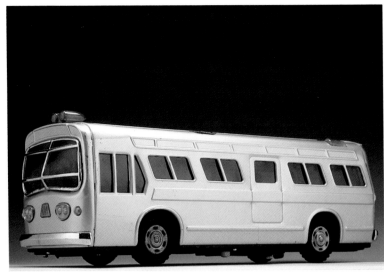

⑩ 1960'S／OMNIBUS／MASUDAYA／410×120×140

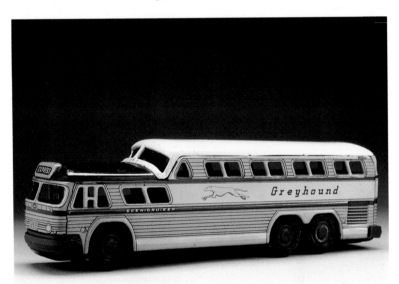

⑩ 1950'S／GREYHOUND BUS／UNKNOWN／275×60×80

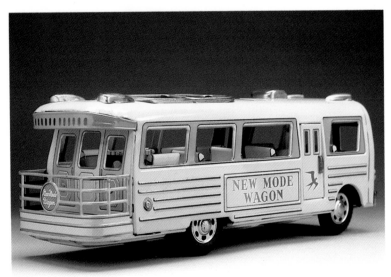

⑩ 1950'S／NEW MODE WAGON BUS／MARUSAN／304×90×100

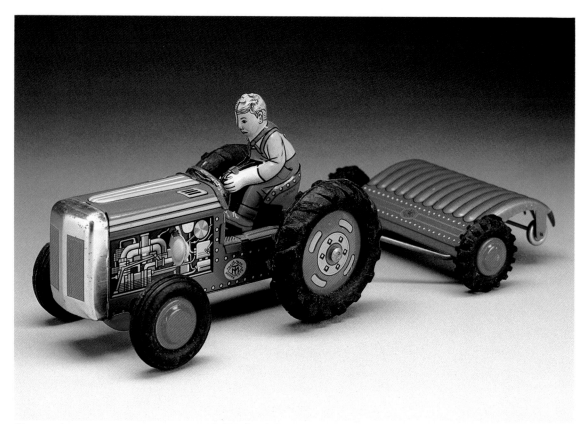

⑩③1950'S／FARM TRACTOR CONSTRUCTION KIT／MASUDAYA

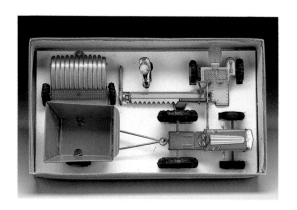

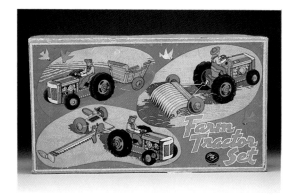

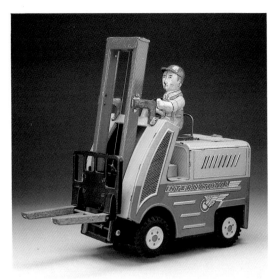

⑩1950'S／LIFTCAR／UNKNOWN／180×85×198

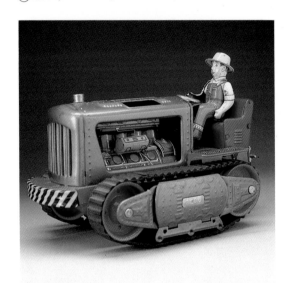

⑩1950'S／TRACTOR／NOMURA／260×120×160

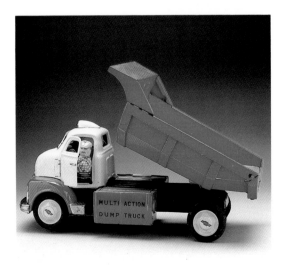

⑩1950'S／CHEVROLET DUMP TRUCK／YONEZAWA
／285×135×125

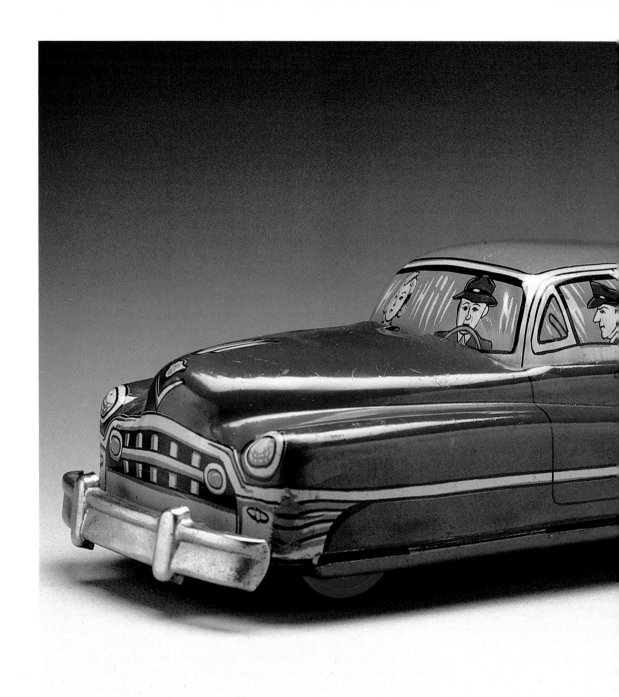

⑩ 1950'S／CADILLAC／UNKNOWN／170×70×55

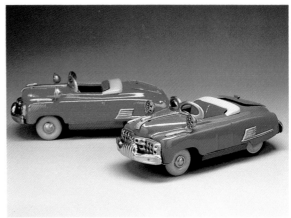

⑩⑨1950'S／POP UP CAR／NIHON BOEKI／200×85×70

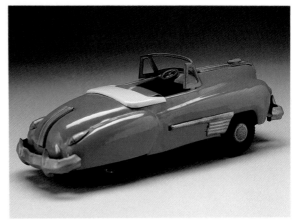

⑩1950'S／AMERICAN CAR／UNKNOWN／185×70×65

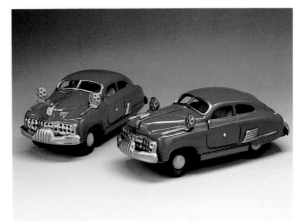

⑪⑫1950'S／POP UP CAR／NIHON BOEKI／200×85×70

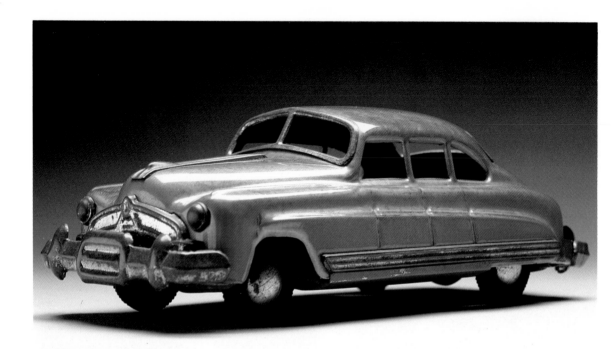

⑬1950'S／1953 HUDSON HORNET／YOSHIYA／250×115×80

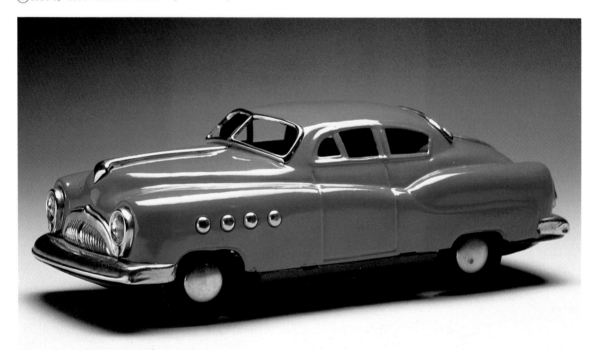

⑭1950'S／BUICK／UNKNOWN／230×95×75

CASE ATTACHED

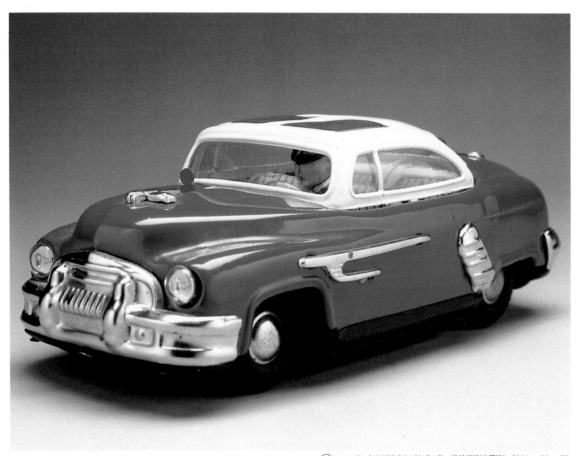

⑮ 1950'S／AMERICAN CAR／UNKNOWN／210×98×75

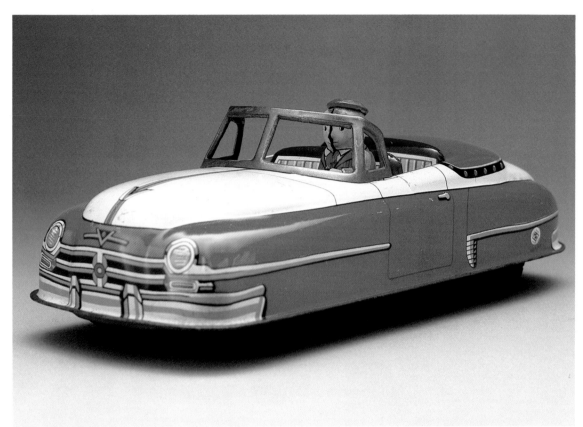

⑯1950'S／SPORTS CAR／MASUDAYA／235×100×80

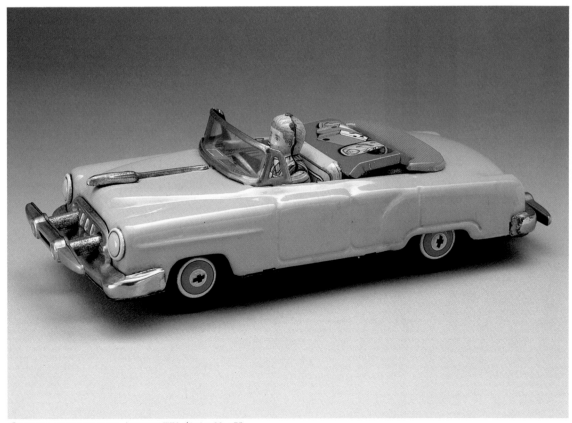

⑰1950'S／SPORTS CAR／UNKNOWN／240×90×75

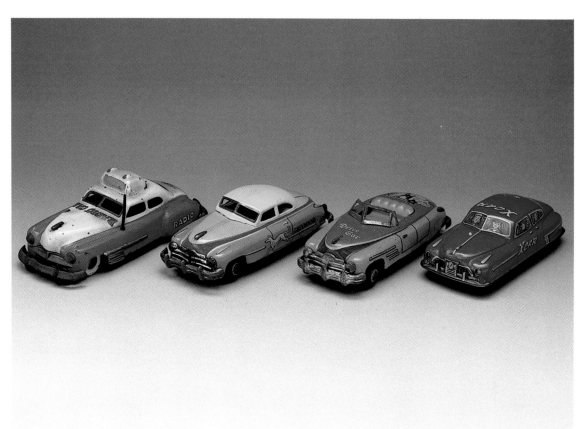

⑪⑱⑲⑳㉑ 1950'S／CARS／UNKNOWN／175×75×60, 155×65×50, 155×65×50, 145×67×50

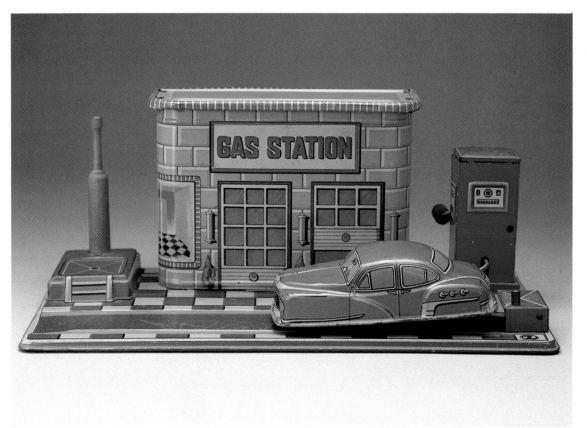

㉒ 1950'S／GAS STATION & CAR／YONEZAWA／130×240×95(GS), 105×55×30(CAR)

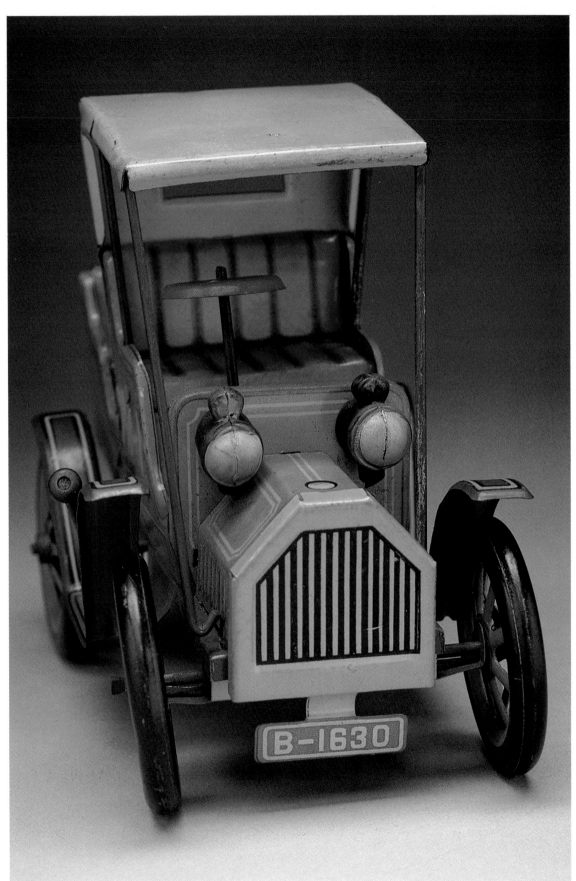

⑫1950'S／CLASSIC CAR／MASUDAYA／140×74×112

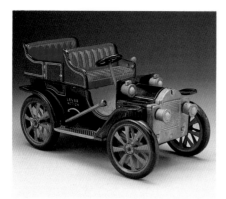

(124) 1950'S／CLASSIC CAR／MASUDAYA
／166×95×97

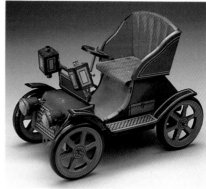

(128) 1960'S／CLASSIC CAR／MASUDAYA
／142×75×95

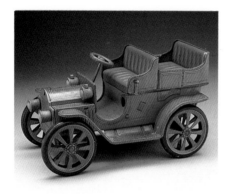

(125) 1950'S／CLASSIC CAR／MASUDAYA
／166×95×97

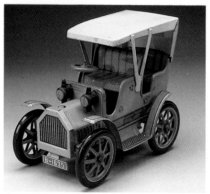

(129) 1950'S／CLASSIC CAR／MASUDAYA
／135×72×109

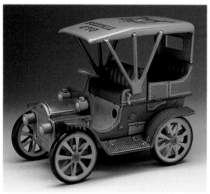

(126) 1950'S／CLASSIC CAR／MASUDAYA
／166×98×135

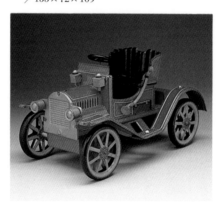

(130) 1950'S／CLASSIC CAR／MASUDAYA
／188×104×98

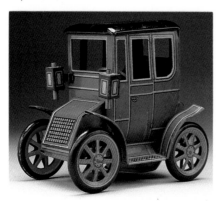

(127) 1950'S／CLASSIC CAR／MASUDAYA
／136×74×118

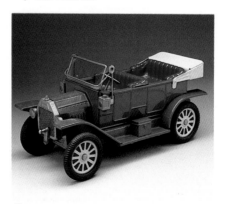

(131) 1950'S／CLASSIC CAR／UNKNOWN
／241×111×120

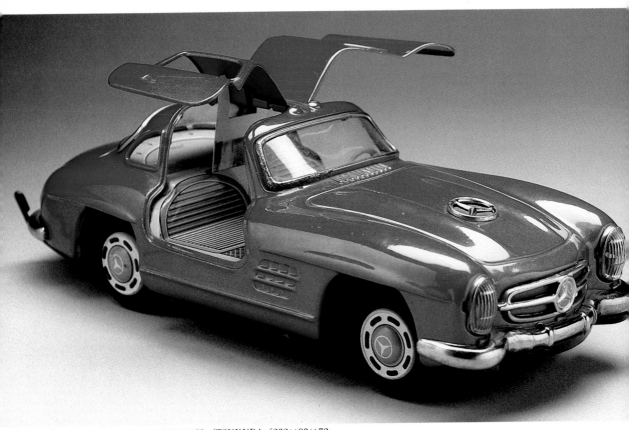

⑬ 1950'S／MERCEDES-BENZ 300SL／TSUKUDA／232×93×72

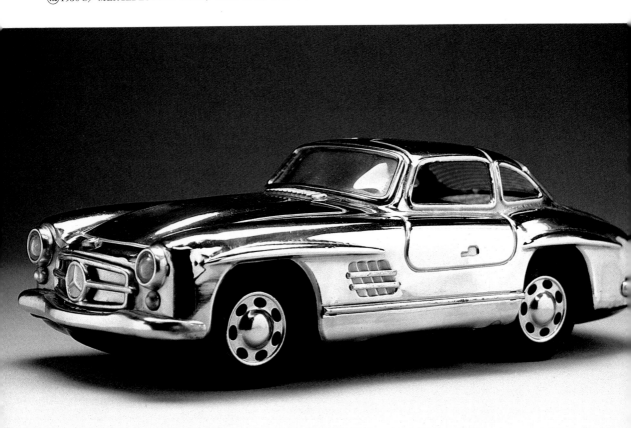

⑬ 1950'S／MERCEDES-BENZ 300SL／MARUSAN／225×97×65

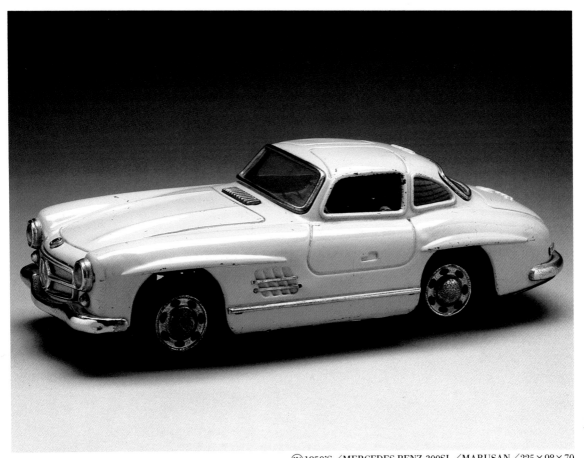

⑬④1950'S／MERCEDES-BENZ 300SL／MARUSAN／225×98×70

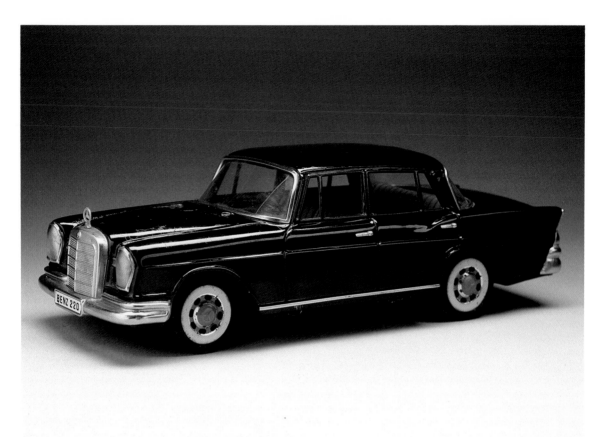

⑬⑤1960'S／MERCEDES-BENZ 220S／BANDAI／265×100×80

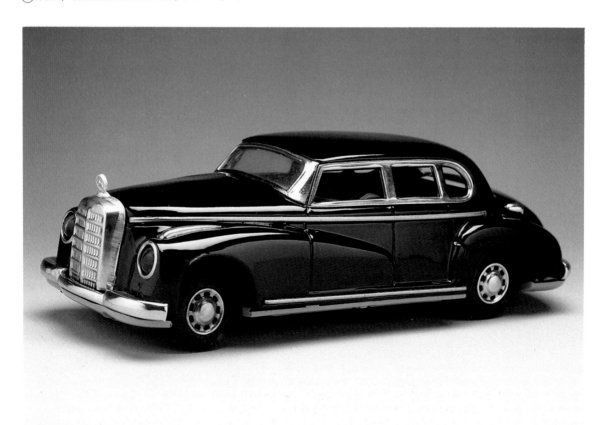

⑬⑥1950'S／MERCEDES-BENZ 300／ALPS／240×95×75

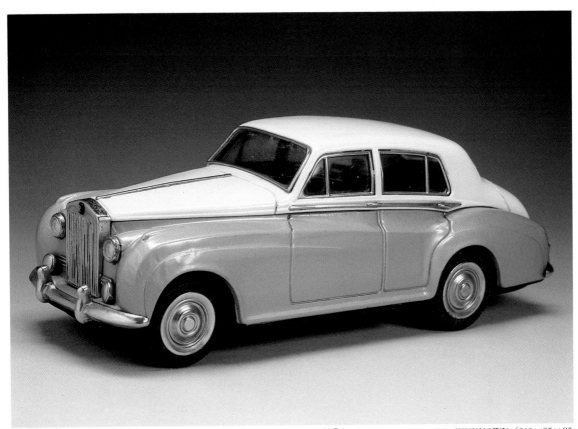

⒀1950'S／ROLLS-ROYCE／UNKNOWN／260×95×95

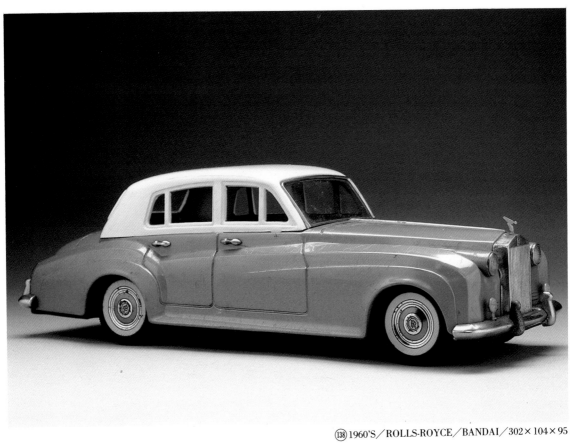

⒀1960'S／ROLLS-ROYCE／BANDAI／302×104×95

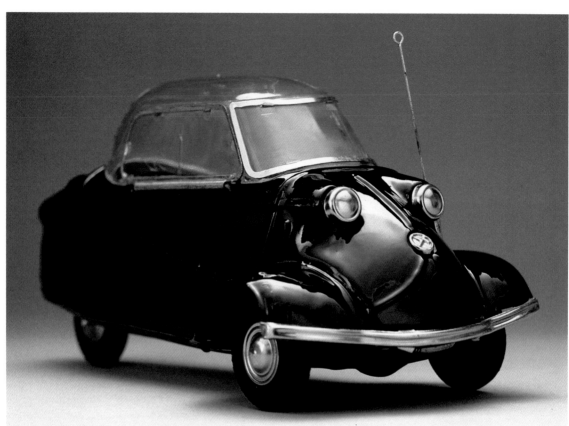

⑬⑨1950'S／MESSERSCHMITT KR200／BANDAI／200×95×90

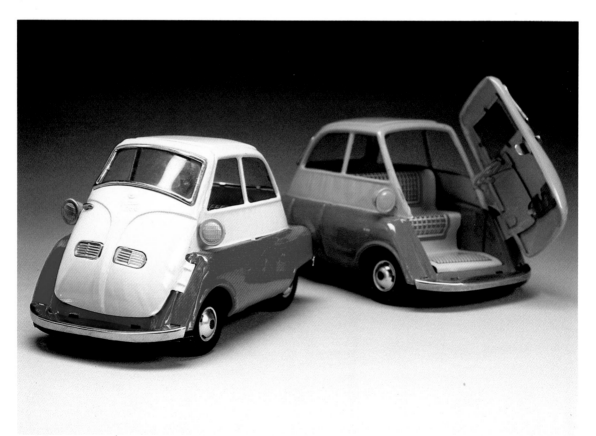

⑭⑩⑭①1960'S／BMW ISETTA (4WHEEL)／BANDAI／70×100×95

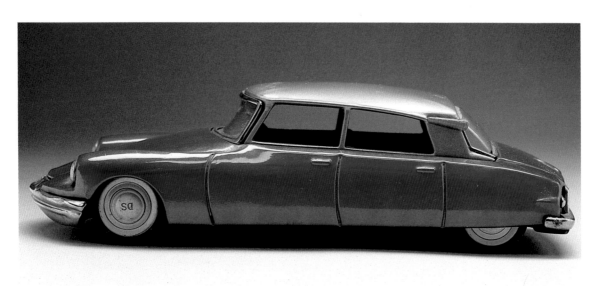

⑭⒉ 1960'S／CITROEN DS19／BANDAI／210×77×60

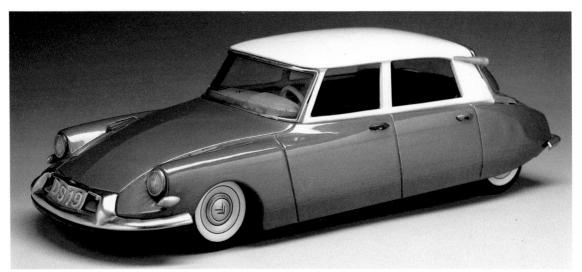

⒁⒊ 1960'S／1960 CITROEN DS19／BANDAI／300×110×90

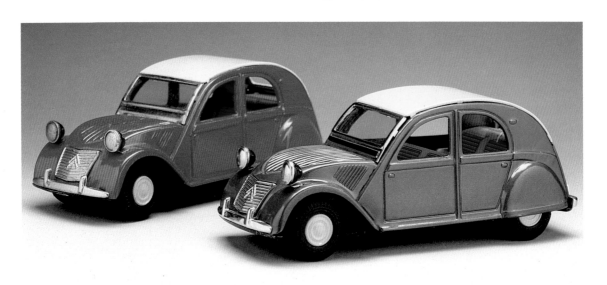

⒁⒋⒁⒌ 1950'S／CITROEN 2CV／DAIYA／210×75×80

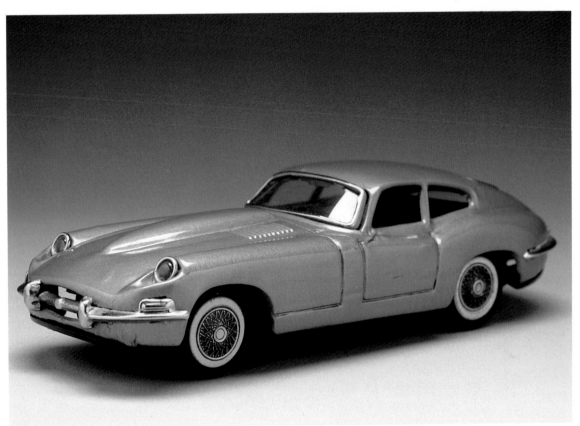

⑭⑥ 1960'S／JAGUAR E-TYPE／TOMIYAMA／310×115×80

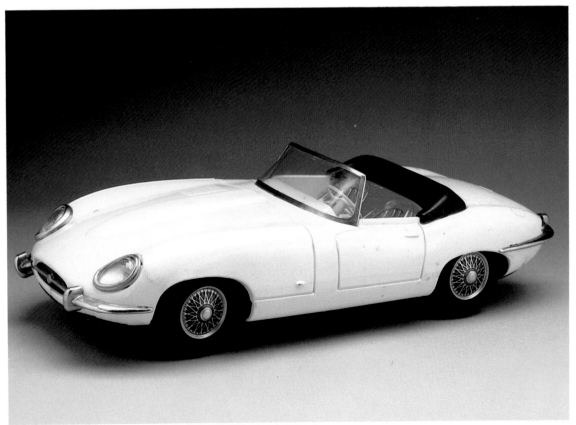

⑭⑦ 1960'S／JAGUAR E-TYPE／BANDAI／210×80×55

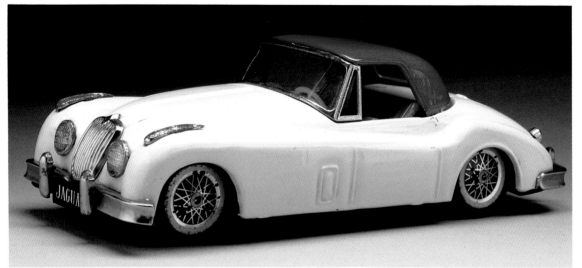

⑭⑧ 1950'S／JAGUAR XK-150／BANDAI／245×100×70

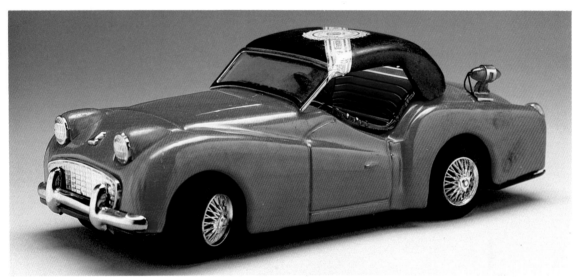

⑭⑨ 1950'S／1958 TRIUMPH TR-3A／BANDAI／215×80×70

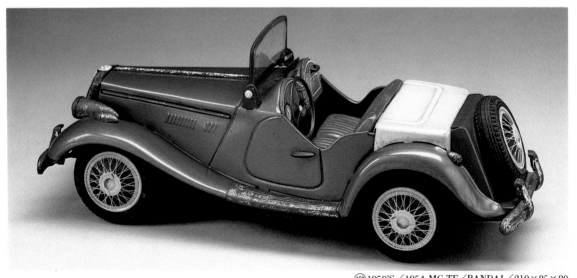

⑮⓪ 1950'S／1954 MG-TF／BANDAI／210×85×80

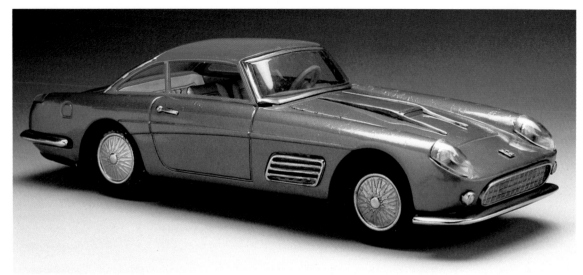

⑮ 1960'S／FERRARI／BANDAI／286×100×78

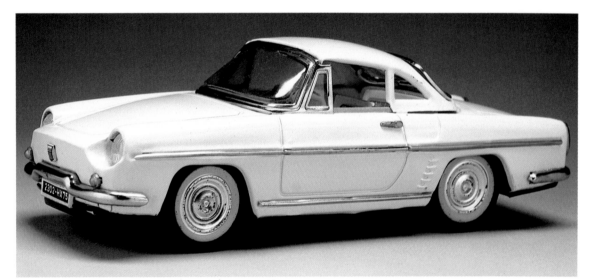

⑯ 1960'S／RENAULT CARAVELLE／ASAHI／230×95×75

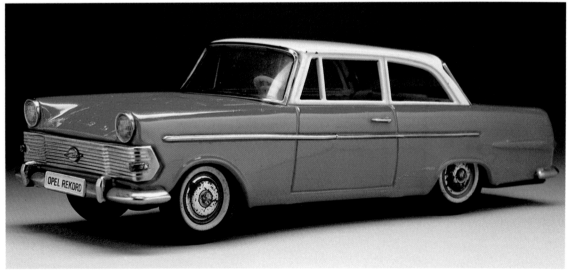

⑱ 1960'S／OPEL RECORD／BANDAI／270×97×80

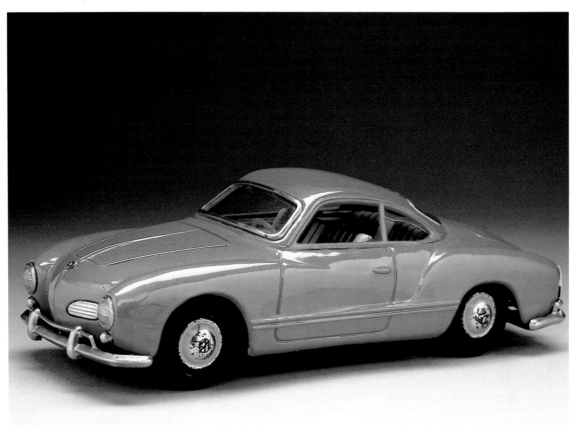

⑮1960'S／1965 VW KARMANN-GHIA／BANDAI／190×78×57

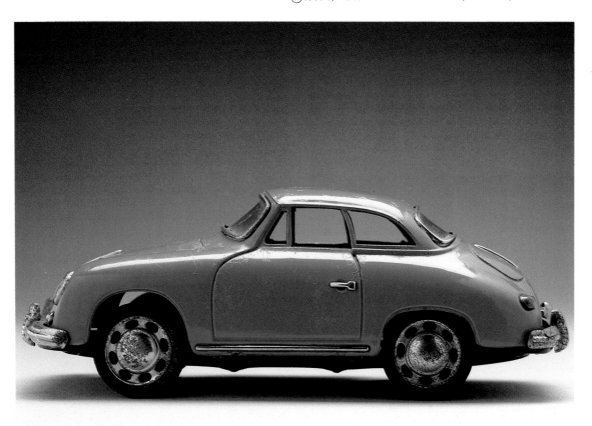

⑯1960'S／PORSCHE 356B／KANAME SANGYO／195×80×73

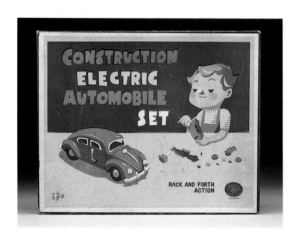

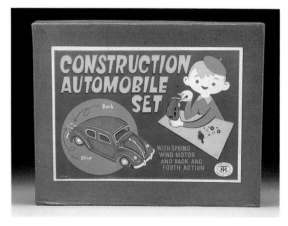

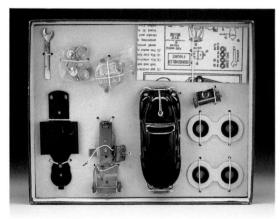

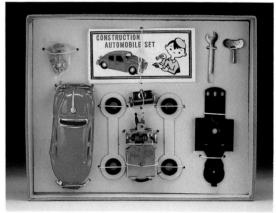

⑯ 1950'S／VOLKSWAGEN CONSTRUCTION KIT
／MASUDAYA

⑰ 1950'S／VOLKSWAGEN CONSTRUCTION KIT
／MASUDAYA

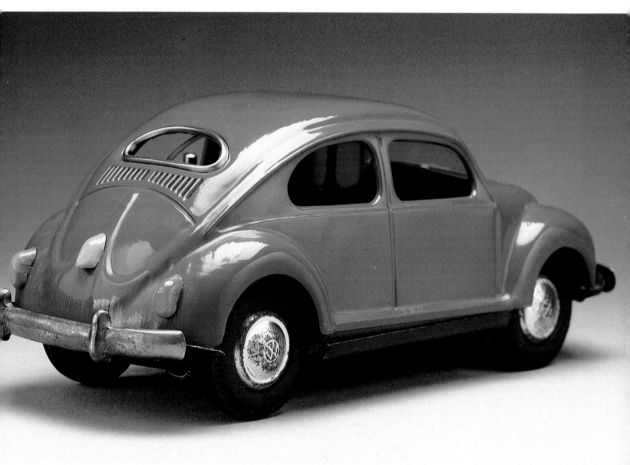

⑮⑧ 1950'S／VW OVAL-WINDOW／MASUDAYA／195×80×125

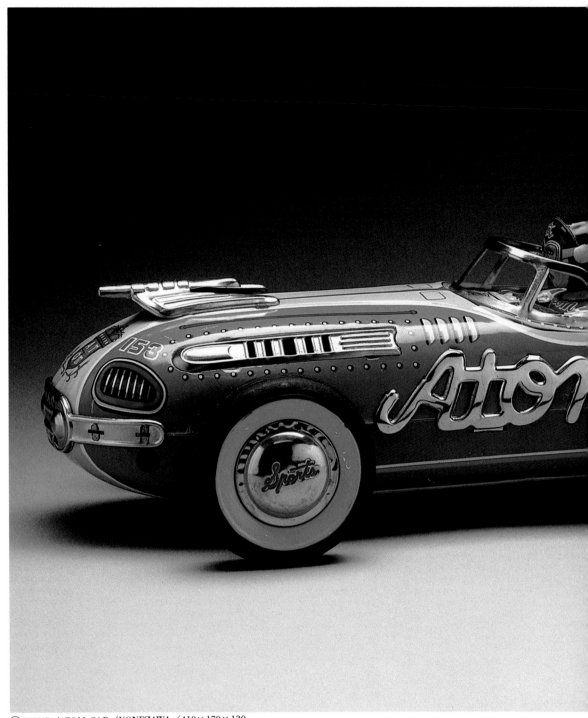

⑮⑨1950'S／ATOM CAR／YONEZAWA／410×170×130

CASE ATTACHED

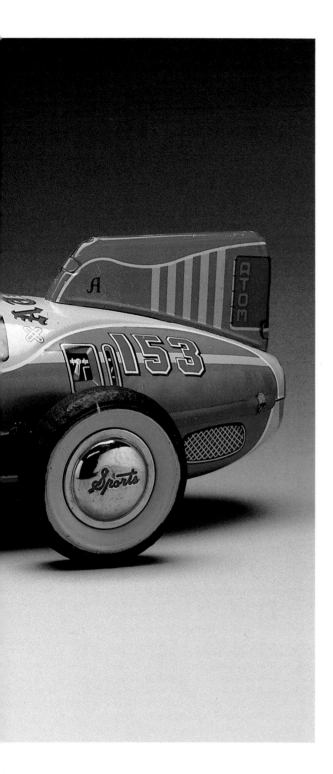

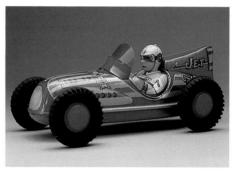

⑯1950'S／JET 7／MARUSAN／210×110×80

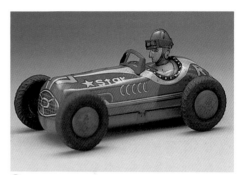

⑯1950'S／STAR-R7／USAGIYA／115×65×50

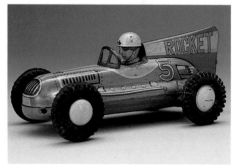

⑯1950'S／ROCKET 5／UNKNOWN／155×75×65

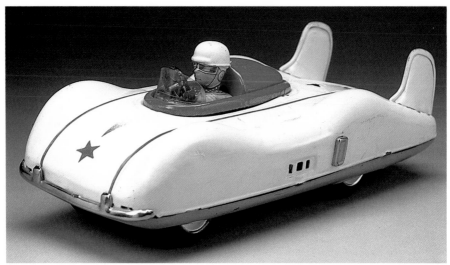

⑯3 1950'S／RENAULT RECORD RACER／SHIBUYA SEISAKUSYO／210×95×70

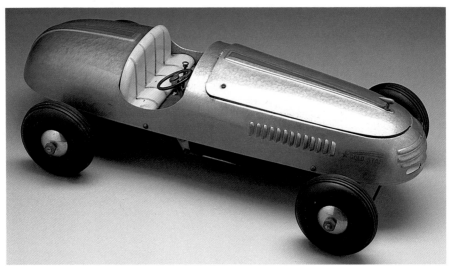

⑯4 1950'S／RACER／UNKNOWN／330×150×95

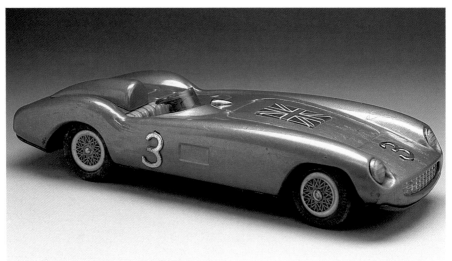

⑯5 1950'S／FERRARI／BANDAI／209×83×45

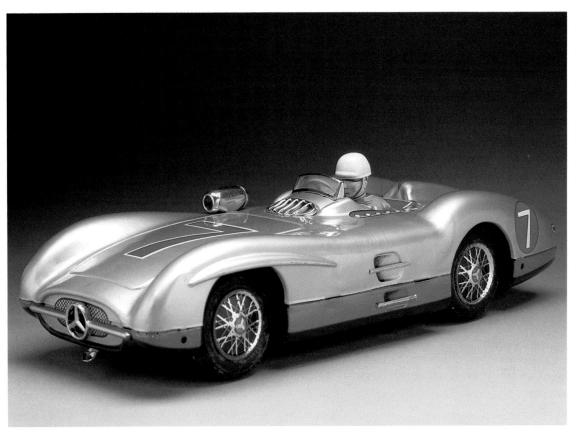

⑯1950'S／MERCEDES-BENZ RACER／MARUSAN／260×100×75

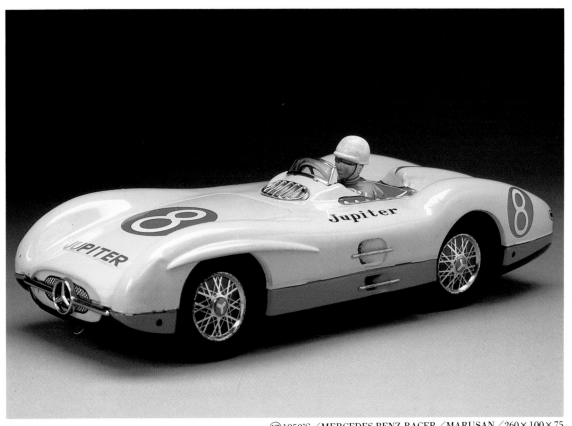

⑰1950'S／MERCEDES-BENZ RACER／MARUSAN／260×100×75

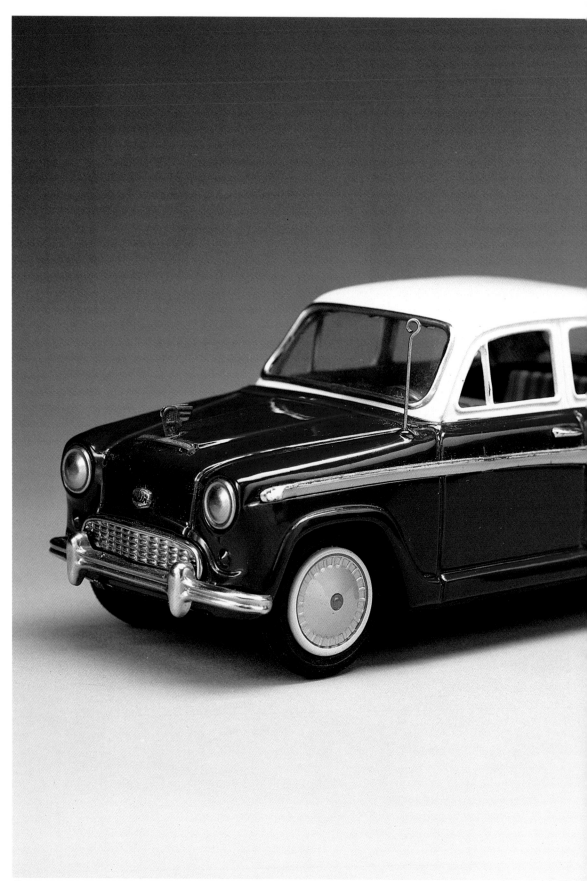

⑯1950'S／AUSTIN A50 CAMBRIDGE(NISSAN)／KOKYU-SHOKAI／200×80×76

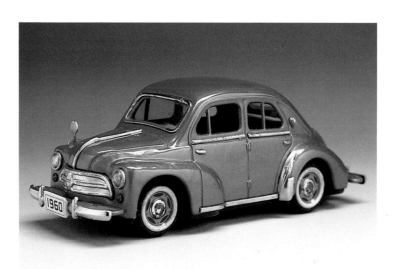

⑯⑨ 1960'S／1959 RENAULT 4CV (HINO)／YONEZAWA／195×75×70

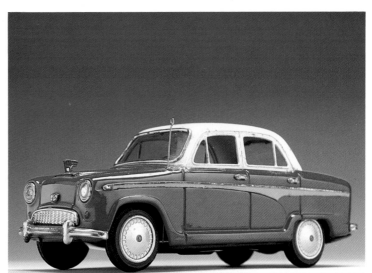

⑰⓪ 1950'S／AUSTIN A50 CAMBRIDGE (NISSAN)／KOKYU -SHOKAI／200×80×76

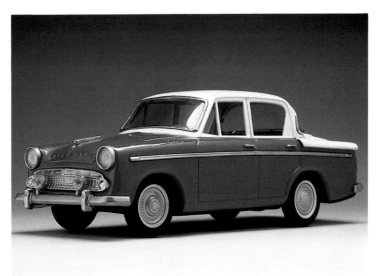

⑰① 1950'S／HILLMAN MINX (ISUZU)／BANDAI／275×100×95

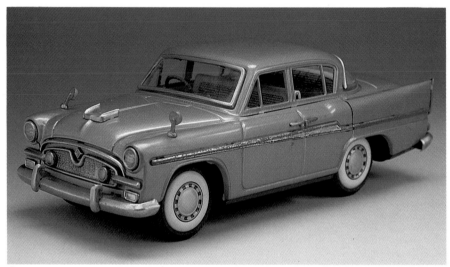

⑰2 1950'S／TOYOPET CROWN／ASAHI／230×95×80

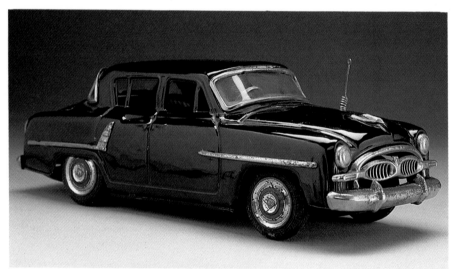

⑰3 1950'S／1956 TOYOPET CROWN RS／ASAHI／206×80×70

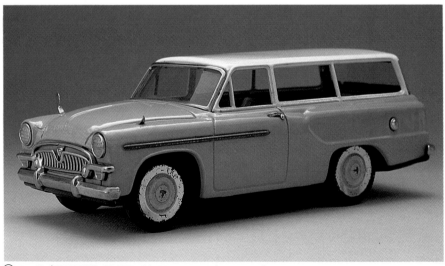

⑰4 1950'S／TOYOPET CROWN MASTER-LINE／BANDAI／235×90×80

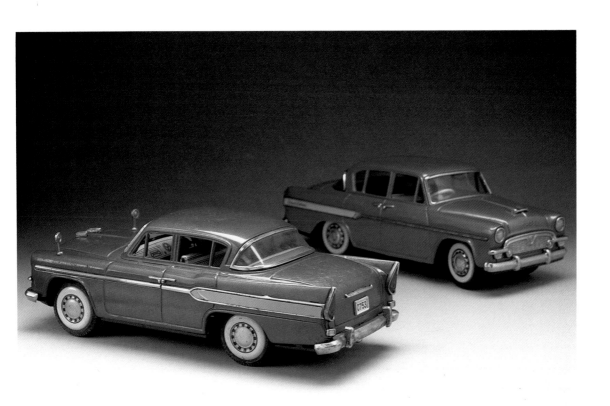

⑰⑯ 1950'S／TOYOPET CROWN／ASAHI／237×95×80(BLUE), BANDAI／225×90×80(BROWN)

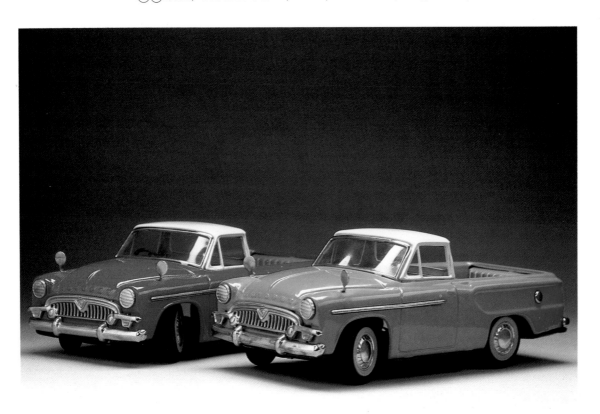

⑰⑱ 1950'S／CROWN PICK-UP／BANDAI／230×90×80

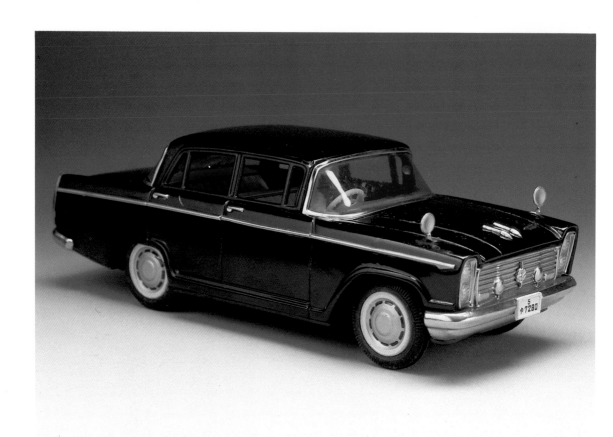

⑰⑨1960'S／1961 CEDRIC DX／ASAHI／250×100×85

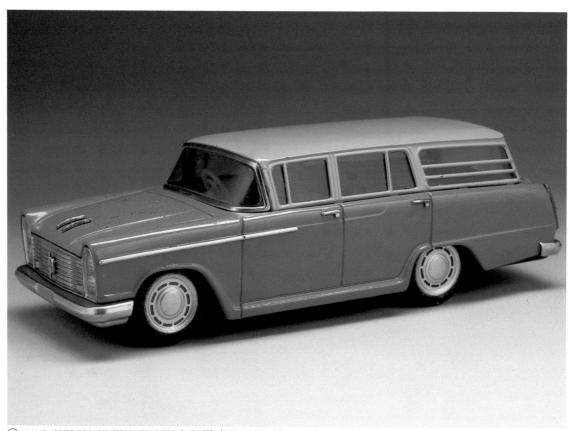

⑱⓪1960'S／CEDRIC STATION-WAGON／ASAHI／270×100×80

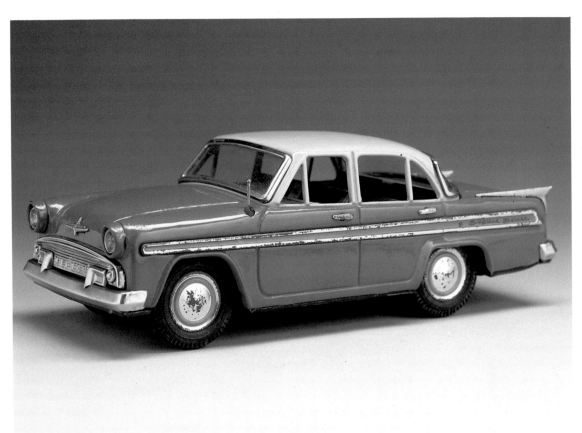

⑱1950'S／1957 PRINCE SKYLINE DX／BANDAI／225×90×75

⑱1950'S／1959 BLUEBIRD P310／BANDAI／222×83×75

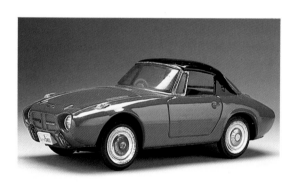

⑱ 1960'S／1965 TOYOTA S800／ASAHI／245×98×85

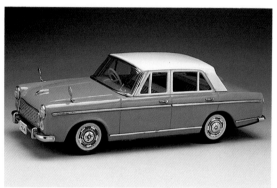

⑱ 1960'S／1962 ISUZU BELLEL／BANDAI／260×100×80

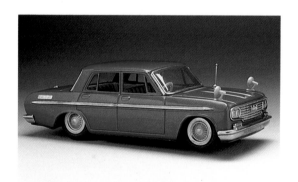

⑱ 1960'S／1964 TOYOPET CROWN 8／YONEZAWA
／255×100×75

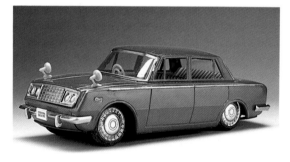

⑱ 1960'S／1964 TOYOPET CORONA／YONEZAWA
／270×95×80

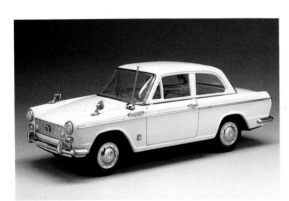

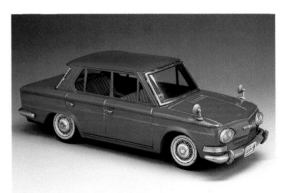

Ⓐ 1960'S／DAIHATSU CONPAGNO BERLINA／UNKNOWN
／258×95×90

Ⓑ 1960'S／HINO CONTESSA／YONEZAWA／280×105×90

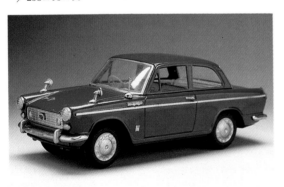

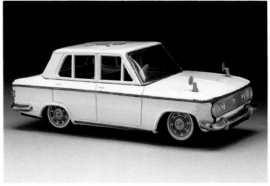

Ⓒ 1960'S／DAIHATSU CONPAGNO BERLINA／UNKNOWN
／258×95×90

Ⓓ 1960'S／MAZDA FAMILIA／BANDAI／225×95×75

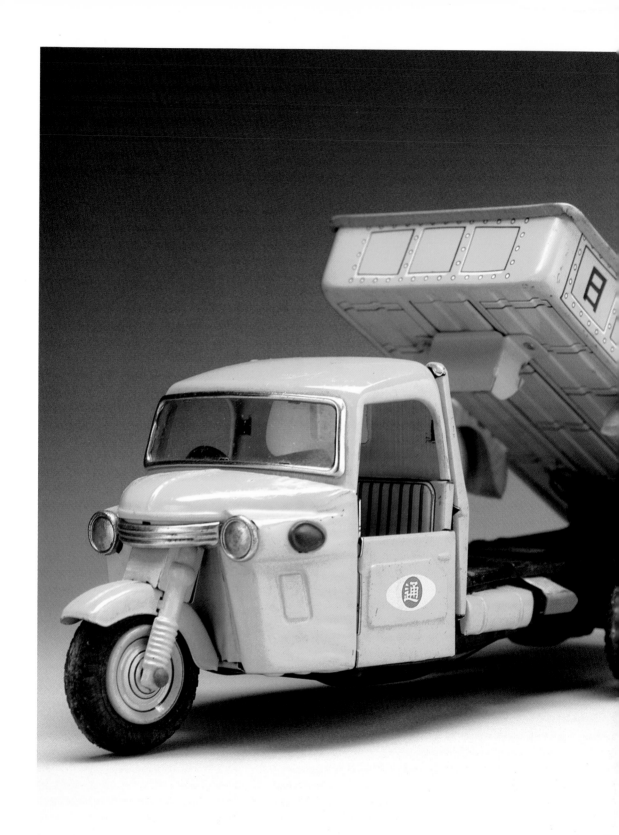

⑲1950'S／DAIHATSU AUTO TRICYCLE／NOMURA／270×90×90

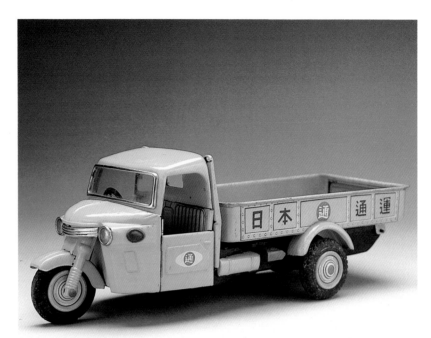

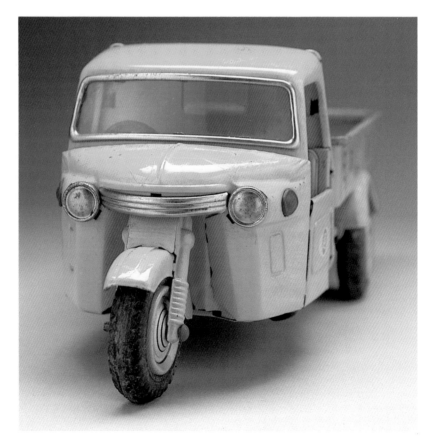

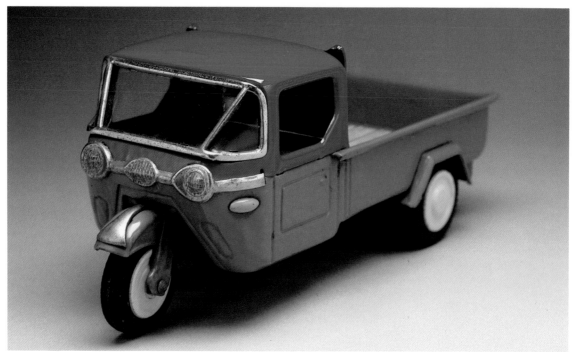

⑲²1950'S／MAZDA AUTO TRICYCLE／BANDAI／210×95×90

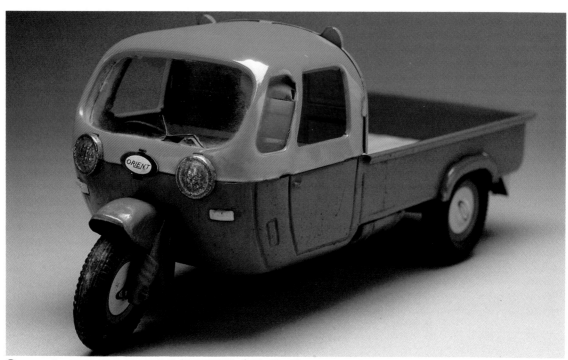

⑲³1950'S／ORIENT AUTO TRICYCLE／YONEZAWA／225×85×90

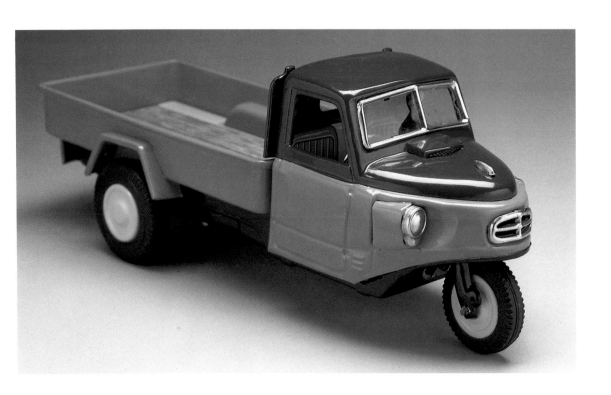

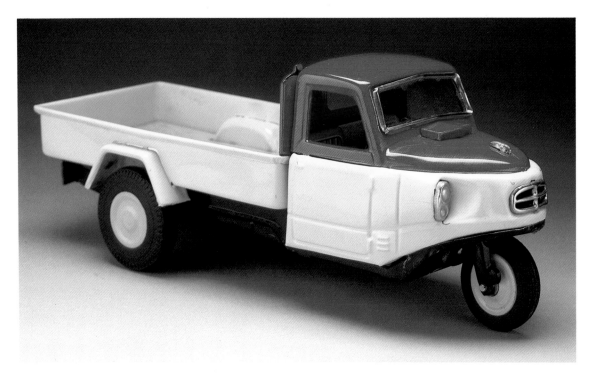

⑲⑲⑨1950'S／MITSUBISHI AUTO TRICYCLE／BANDAI／260×95×100
CASE ATTACHED

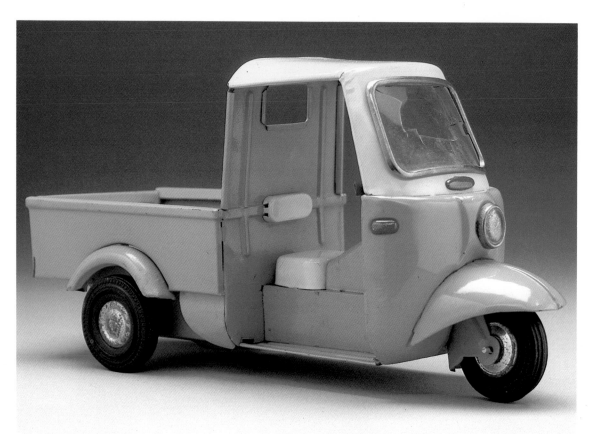

⑲⑥1950'S／DAIHATSU MIDGET／YONEZAWA／205×85×108

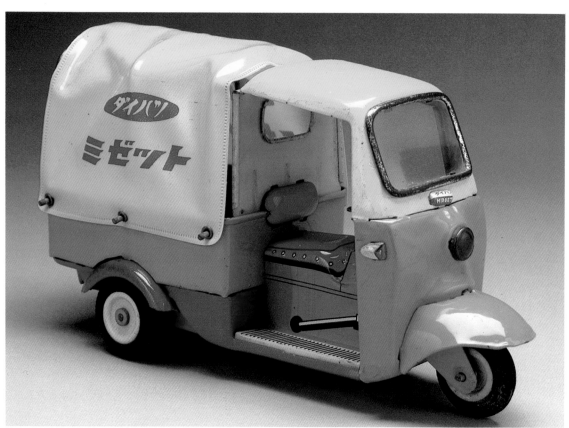

⑲⑦1950'S／DAIHATSU MIDGET／KOKYU SHOKAI／165×70×95

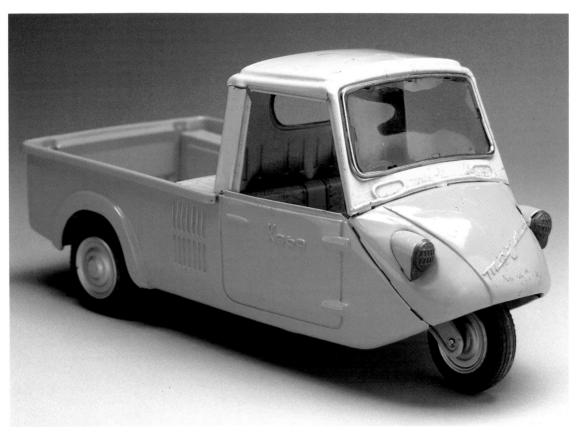

⑲1950'S／MAZDA AUTO TRICYCLE K360／BANDAI／190×85×88

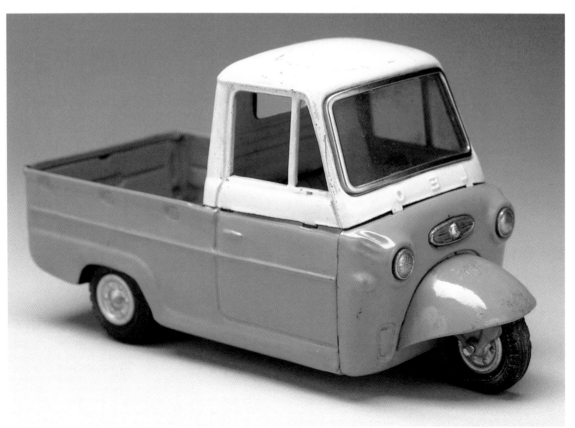

⑲1950'S／MITSUBISHI AUTO TRICYCLE LEO／BANDAI／155×70×85

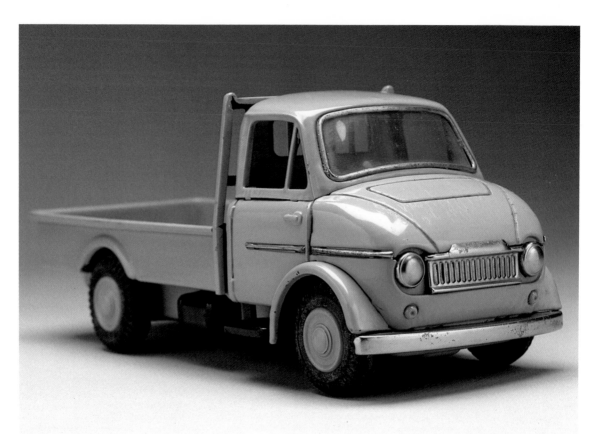

200 1950'S／MAZDA TRUCK／BANDAI／218×84×90

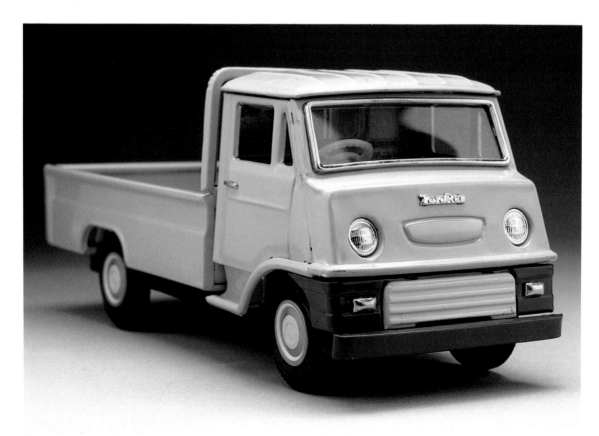

201 1950'S／TOYOACE TRUCK／ASAHI／225×90×100

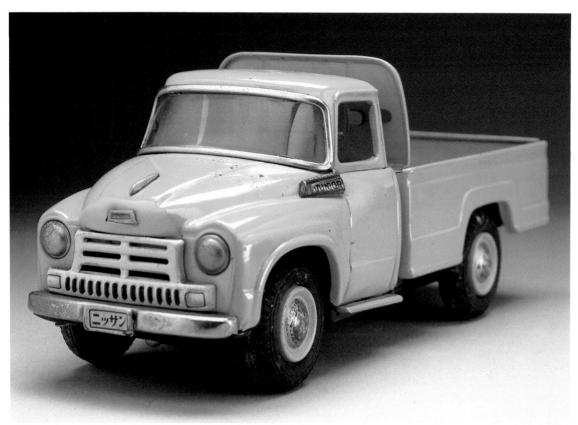

㉒1950'S／NISSAN JUNIOR TRUCK／BANDAI／205×73×85

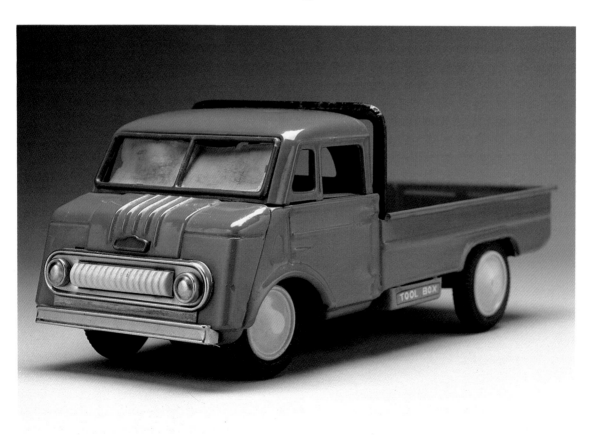

㉓1950'S／TOYOACE TRUCK／UNKNOWN／232×103×92

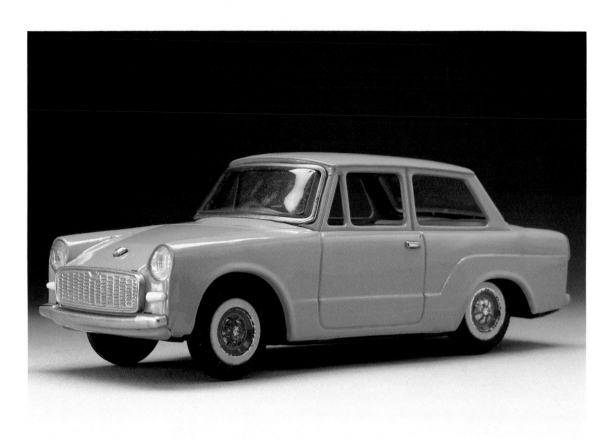

㉔ 1960'S／TOYOTA PUBLICA／BANDAI／210×80×75

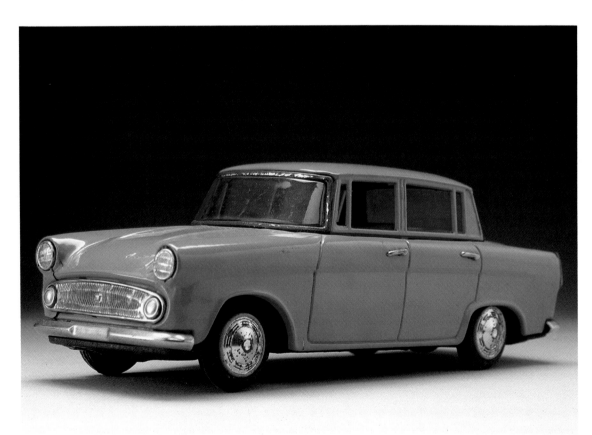

㉕ 1960'S／TOYOPET CORONA／ASAHI／225×80×80

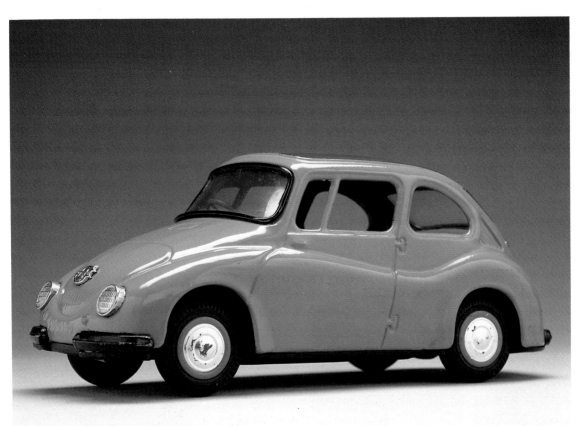

㊐1960'S／SUBARU 360／BANDAI／200×85×83

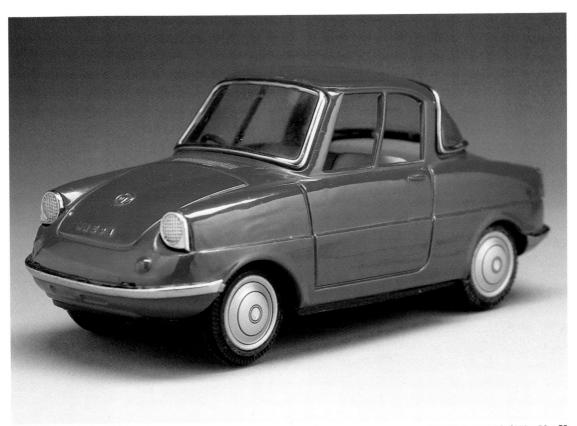

㊕1960'S／MAZDA R360 COUPE／BANDAI／180×80×75

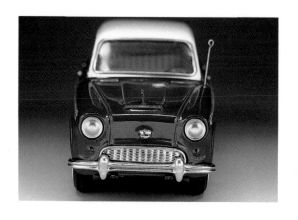 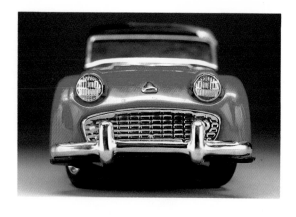

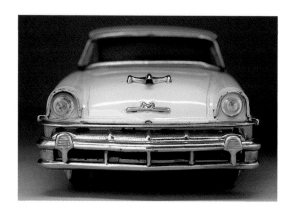 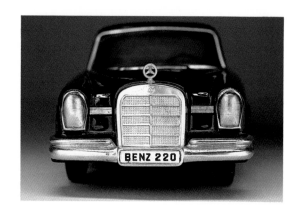

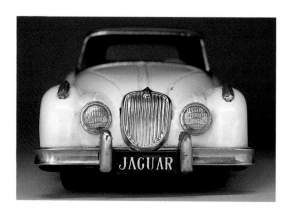 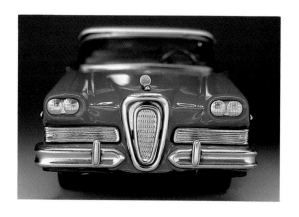

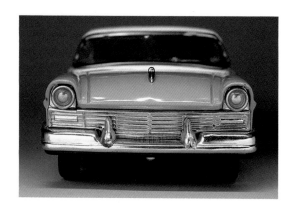 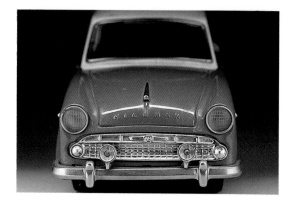

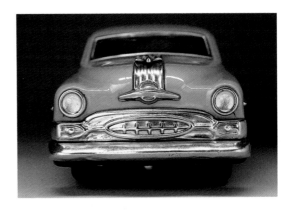

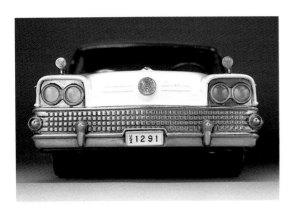

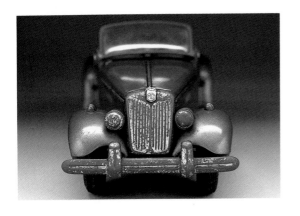

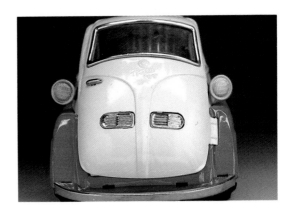

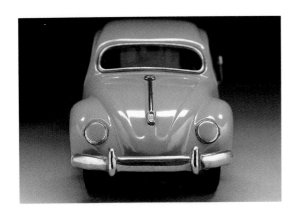

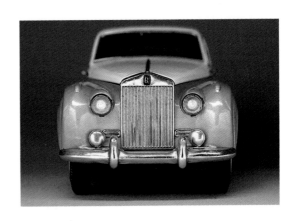

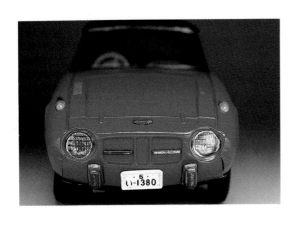

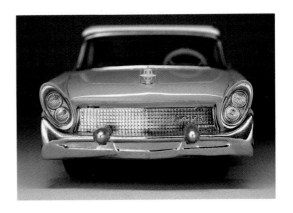

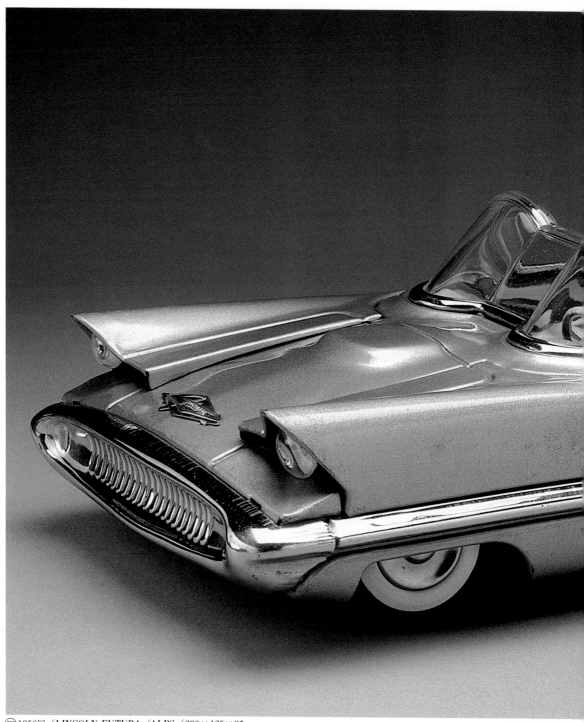

⑳ 1950'S／LINCOLN FUTURA／ALPS／280×125×85

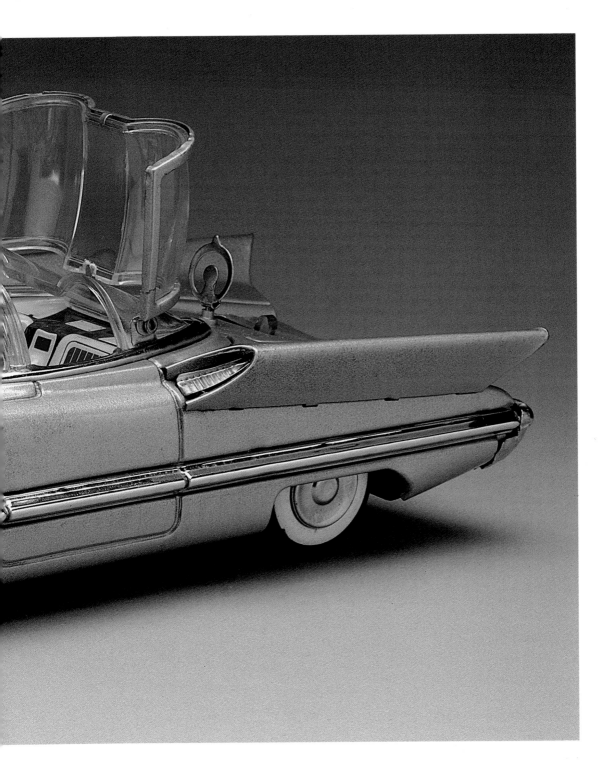

CASE ATTACHED

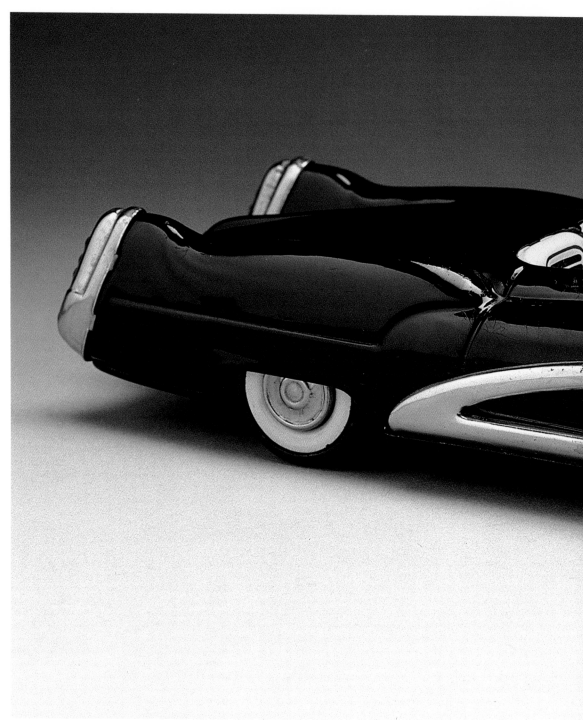

209 1950'S／BUICK LE SABRE／YONEZAWA／200×75×55

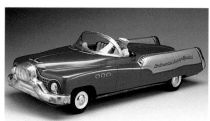

210 1950'S／DREAM CAR／UNKNOWN／345×125×90

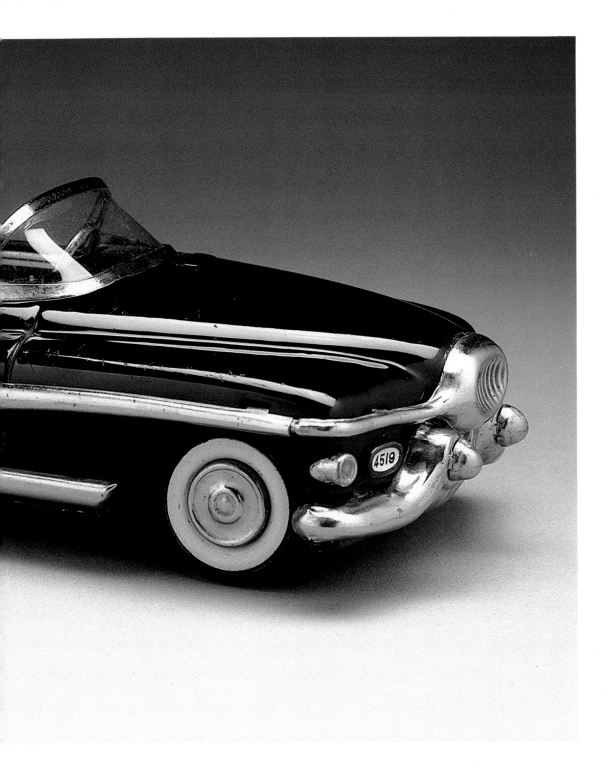

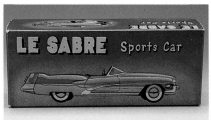

CASE ATTACHED

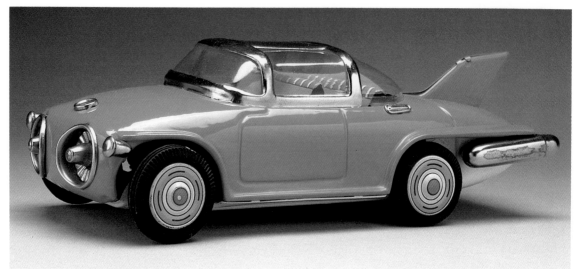

㉑㉑ 1950'S／GM TURBINE CAR／ASAHI／225×85×70

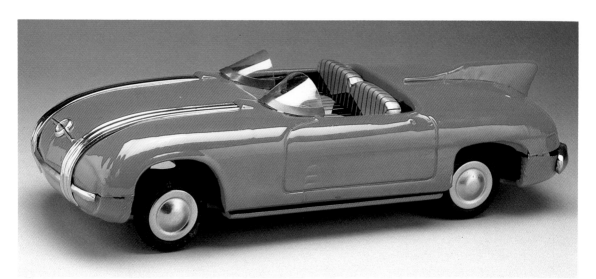

㉒㉒ 1950'S／PONTIAC DREAM CAR／MITSUHASHI／255×95×65

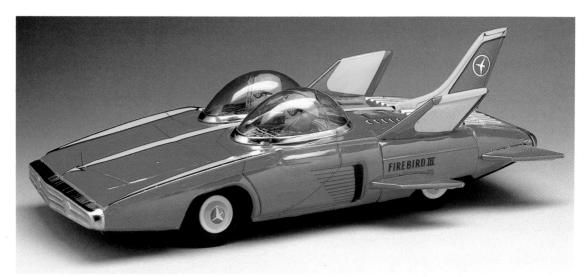

㉓㉓ 1960'S／DREAM CAR／ALPS／290×145×90

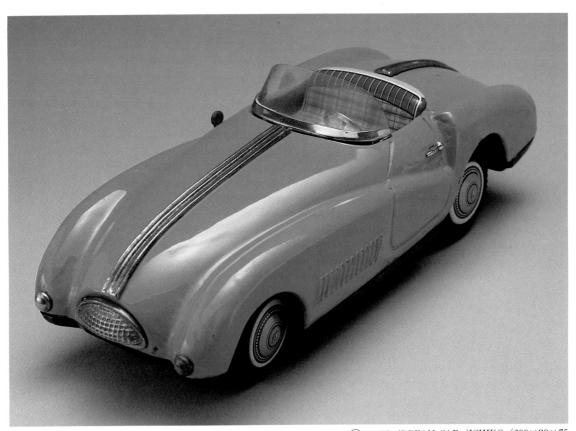

㉔ 1950'S／DREAM CAR／ICHIKO／200×80×75

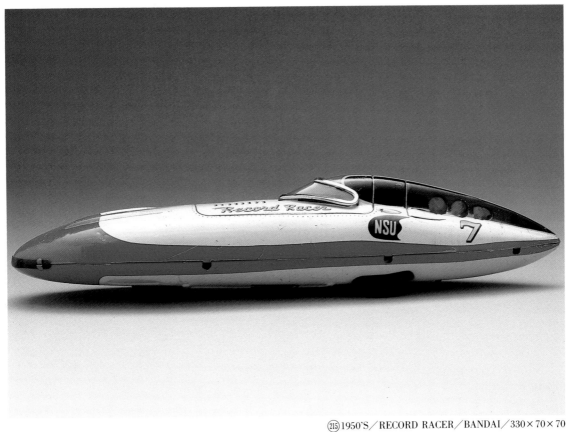

㉕ 1950'S／RECORD RACER／BANDAI／330×70×70

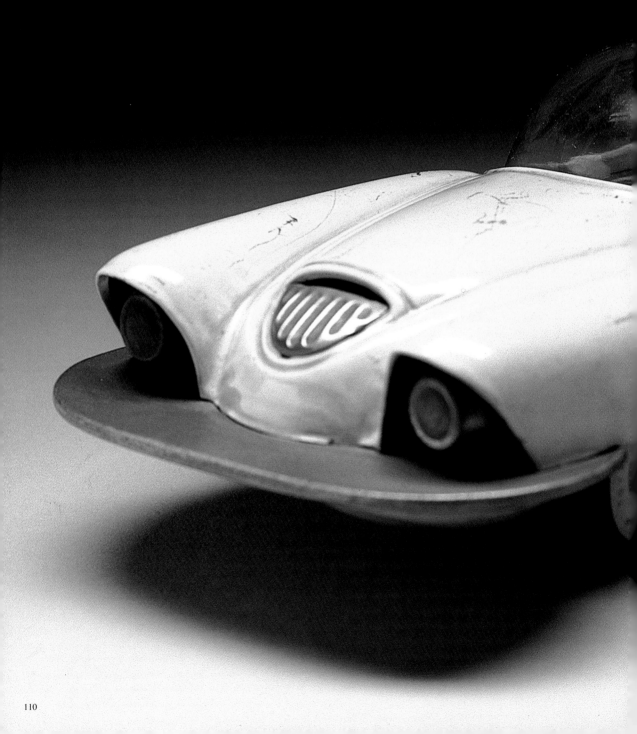

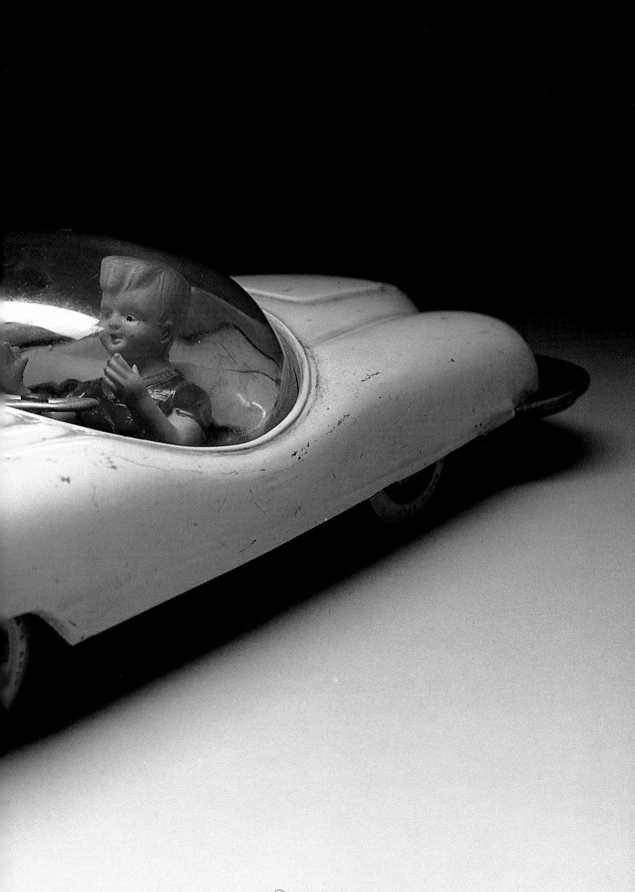

216 1950'S／DREAM CAR／LINE MAR／290×130×70

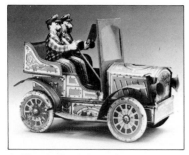

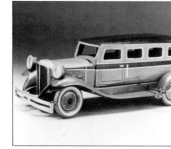

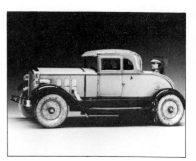

1. **Classic Car** (Y. Suzuki) page 3
This toy is soldered together
and probably was manufactured in
Japan in the late nineteenth or early
twentieth century, during Japan's
expansionist period. In fact, the
passengers in the flower and Japanese-
flag festooned car look intently at
a map of Manchuria and Sakhalin,
one-time Japanese possessions.

2. **Children Bus** (Tomiyama) page 4
This is a rare toy—a copy of a
pre-World War II bus. As the picture
on the package indicates, the toy is a
combination of materials; wood for
the body and tin for the detail work.

3. **Classic Car** (Unknown) page 6
The unknown manufacturer has made
a very precise replica of a 1930s car.
The car lights work on a battery; a
spring mechanism causes the passen-
ger to pop up from the rumble seat.

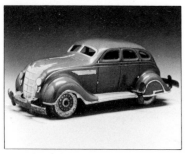

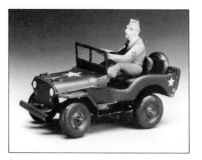

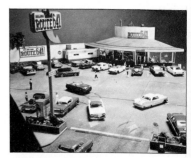

4. **DeSoto** (Masudaya) page 7
Made in the pre-war period, this
car moves by a spring mechanism and
has tin-plate wheels and a body of
celluloid. Wheels can be turned left
or right.

5. **Jeep** (Kosuge Toys) page 8
This is a good example of a toy
that captures a moment in history:
the arrival of American GIs in
Japan in 1945.

6. **Highway Diner** (Garage 641)
pages 10-11
Members of Garage 641, a plastic
model cars collectors club, built this
imaginary stop along one of America's
West Coast highways. All of the
model cars are of the Bandai Red Box
series (1:24 scale). For another view
of the diner, see pages 50-51.

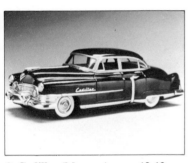

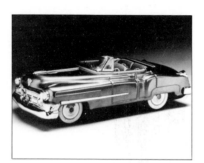

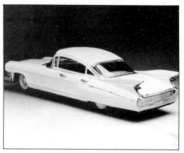

8. **Cadillac** (Marusan) pages 12-13
In the realm of tin-plate autos, Marusan's Cadillac is one of the gems of craftsmanship. More than a toy, it recreates the original exactly, right down to the undefinables, like elegance and class.

14. **Cadillac** (Nomura) page 16
A candy-colored 1954 Cadillac. Because it was for export, this toy was made of aluminum, so it would be lighter.

18. **Cadillac** (Bandai) page 19
From 1957 to 1959 American car makers were engaged in a great styling race which included coming out with the most original tail fins. One of the all-time greats for fins was the 1959 Cadillac.

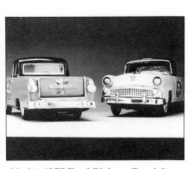

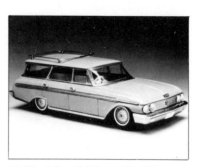

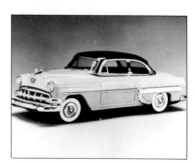

20. 21. **1957 Ford Pickup** (Bandai) page 20
The mainstream of American cars in the fifties were two-tone. Even the basic hard-working pickup truck was painted two colors—it gave the driver a psychological boost.

22. **Ford Ranch Wagon** (Asahi) page 21
All that's missing are kids, a dog, and a picnic lunch. The model copies the original Ford wagon exactly, including side windows that roll down only halfway.

24. **1954 Chevrolet Bel-Air** (Marusan) pages 22-23
Marusan introduced this car along with its model of the Cadillac. Well-known for high quality toys, Marusan proves its reputation in the glittering chrome and beautifully reproduced body lines of this toy.

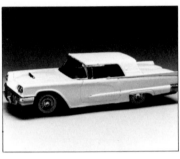

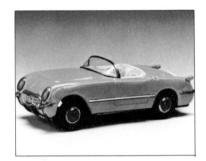

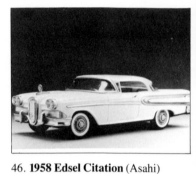

43. 1958 Ford Thunderbird (Bandai)
page 26
In 1958, Ford came out with a totally
new look for its well-known T-bird.
The toy is a model of that version.

45. 1953 Chevrolet Corvette
(Bandai) page 27
When the first Corvettes appeared in
1953, the sticker price was $3,512.
Three years later the two-passenger
sportscar had a rival on the market—
the Ford Thunderbird (see
Toy No. 58).

46. 1958 Edsel Citation (Asahi)
page 28
The Edsel, named for the son of Henry
Ford, made its debut in 1957. Public
opinion was that the front design was
too modern, and sales would remain
dismally low until Edsel production
stopped in the winter 1959. It was
one of America's unlucky cars.

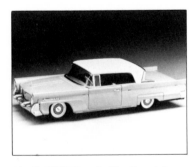

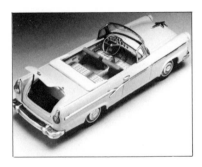

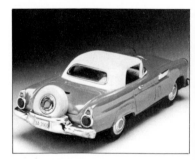

**48. 49. 1958 Lincoln Continental
Mark III** (Bandai) page 30
Characteristic of this particular
Lincoln was the elongated oval shape
of the headlights. The car came in
vivid colors, hardtop or convertible
(Toy No. 49).

57. 1956 Ford Fairlane (Bandai)
page 34
The convertible was the car for
the freewheeling, carefree American
lifestyle: a combination of sun, wind
and mobility. The Fairlane summed
up all that was good about life in the
fifties. This toy model features a trunk
that opens and reclining front seats.

58. 1956 Ford Thunderbird
(Unknown) page 34
Ford introduced this sports car
to compete with Chevrolet's Corvette,
and this particular model became one
of its best known cars. The T-birds
from 1955 to 1957 are now coveted
possessions.

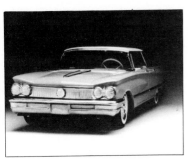

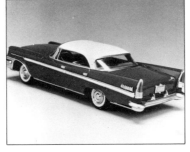

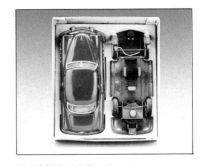

60. 1960 Buick Invicta (Ichiko) page 35
There was nothing subtle about the change in car design at the start of the sixties. The rounded lines of the fifties were replaced with sharp, angular shapes. The Ichiko Buick shows the severe sixties look; this one still bears the label, "Ichiko's new toy."

61. 1957 Chrysler New York (Alps) pages 36-37
Larger than most toy cars, this Chrysler by Alps measures 35 centimeters in length, and a lot of that is tail fin—fins made the '57 Chrysler famous. It also had beautiful chrome side trim.

62. 1953 Buick Roadmaster Construction Kit (Marusan) page 38
Assembling the kit was simply a matter of joining body to chassis. Headlights would light by friction. The box mistakenly describes the toy as a 1:600 scale model.

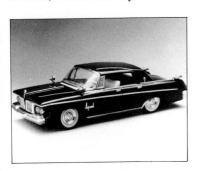

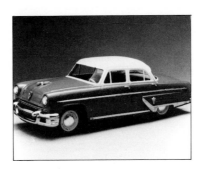

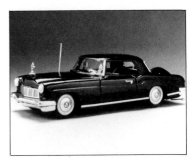

79. 1962 Chrysler Imperial Le Baron (Asahi) page 42
Exclusive features of the 1962 Imperial were the front body design, the shape of the taillights and the streamlined body. Asahi made full use of available technology in the production of this toy.

80. 1954 Lincoln (Yonezawa) page 44
American cars of the fifties were outstanding not simply for their design but also for color. While other countries were turning out sombre and muted colors, American makers chose bright and flashy hues, like the blue and white on this toy model.

81. 1957 Lincoln Continental Mark III (Line Mar) page 44
Line Mar designed headlights and taillights for this toy that actually shone with more intensity than those on the full-size car.

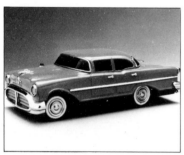

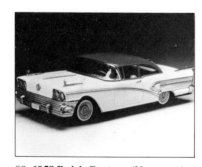

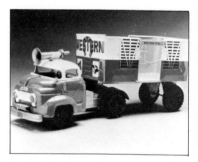

85. 1956 Oldsmobile Super 88
(Masudaya) page 46
American car makers in the fifties
usually put their signature mark up
front. On the '56 Olds, it was front
grill shaped like the open jaws of
a whale. This toy model is radio-
controlled.

88. 1958 Buick Century (Yonezawa)
page 48
The jazzy red and white color scheme
was typical of fifties cars like this
Buick Century. Buick made 7,241 of
these cars in 1958; the original
price was $3,300.

89. Trailer Truck (Marusan) page 52
This outsized model (45 centimeters
in length) exhibits the rounded lines
that characterized both cars and trucks
in the fifties. For fun, the makers have
added an out-of-scale horn on the
roof of the cab.

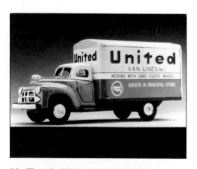

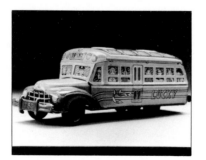

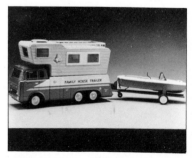

92. Truck (Unknown) page 53
There's something friendly and
familiar about this toy. It's definitely
attention-grabbing, with its bold
colors and big United sign.

98. Omnibus (Nomura) page 55
Old buses like this one, with the
protruding front hood, can still be
seen once in a while, living out their
twilight years as tour buses. But in the
fifties, they were in common use and
that's why toy manufacturers made so
many toys like this one. An interesting
feature of this model is the addition of
passengers and driver in the windows.

99. Family House Trailer (Bandai)
page 56
Japanese people learned about
the American way of life in the fifties
through TV and magazines. This toy
trailer home and motorboat seemed to
typify to them the leisure life
that Americans led.

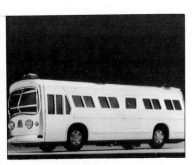

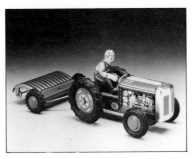

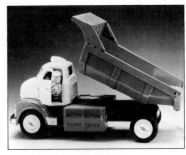

100. Omnibus (Masudaya) page 57
One of the early radio-controlled
toy buses, it was introduced by Masu-
daya at the height of the remote-
control car's popularity. This model
is painted a high tech silver color.

103. Farm Tractor Construction Kit
(Masudaya) page 58
Included in the kit were an American
farmer, his rig, and attachments for
plowing, harvesting and carrying.
The farmer's clothing is nicely
detailed.

106. Chevrolet Dump Truck
(Yonezawa) page 59
This toy duplicates a fifties dump
truck in every way. A battery-operated
motor (the two fuel tanks are battery
boxes) raises the bed of the truck
while the driver swings out of the
cab to have a look.

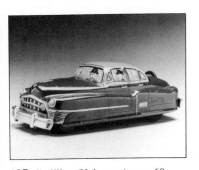

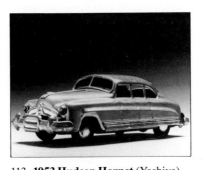

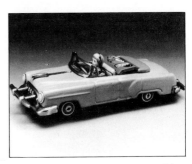

107. Cadillac (Unknown) page 60
All it takes is a head-on collision and
this toy hardtop changes into a
convertible.

113. 1953 Hudson Hornet (Yoshiya)
page 62
It's only a toy, but still this tiny
Hudson maintains a very expressive
appearance. The toy is particularly
interesting for the faded color of the
paint and "H" insignia on the back.

117. Sports Car (Unknown) page 64
The battery-operated sequence of
actions is fairly sophisticated: the car
runs forward until it hits an object,
then backs up and drives forward
again until hitting another obstacle.
The driver has a suitably moronic
expression.

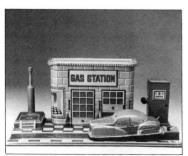

122. Gas Station and Car
(Yonezawa) page 65
In an elaborate series of motions,
the car's friction motor becomes
charged as the fuel pump handle is
turned. Once revved up, the car
runs forward.

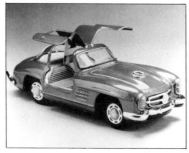

132. Mercedes-Benz 300SL
(Tsukuda) page 68
From 1954 to 1957, the 300SL was
Mercedes-Benz's top-of-the-line
sports car. The name "gull wing" was
derived from the unconventional—
yet stylish—way the doors
opened.

135. Mercedes-Benz 220S (Bandai)
page 70
Tail fins are considered an American
contribution, but in 1959, Mercedes-
Benz introduced the 220S—with
fins. In a departure from other German
auto makers, Mercedes-Benz stuck
with this tail fin design feature
with all its cars of the time.

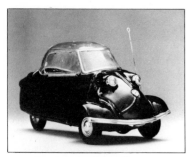

139. Messershmitt KR200 (Bandai)
page 72
This strange-looking mini car
was developed by the West German
company best known for its airplanes.
In fact, their car could be thought of
as a "fighter plane on wheels." There
are two wheels in front and one in
back. The KR200 was made from
1955 to 1964.

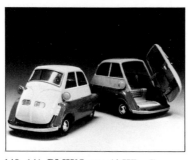

140. 141. BMW Isetta (4-Wheel)
(Bandai) page 72
"Bubble Cars" were made by
BMW from 1955 to 1962. Although
better known as a manufacturer of
luxury sports cars, BMW produced
this model for Isetta of Italy as
a popular, low-cost car.

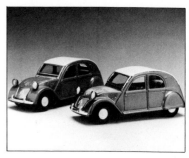

144. 145. Citroen 2CV (Daiya)
page 73
Its unique styling earned it such
nicknames as the "Ugly Duckling"
and the "Tinplate Pig," but the 2CV
was France's solution to economic
motoring. The 2CV with hydraulic
rear suspension has been in pro-
duction since 1948.

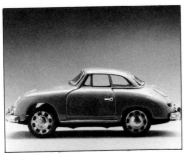

147. **Jaguar E-type** (Bandai) page 74
The celebrated Jaguar E-type made
its debut in 1961, bringing overnight
acclaim to the English manufacturer.
The grace and balance in composition
were strikingly beautiful and the car
remained in production for 14 years.

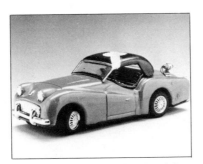

149. **1958 Triumph TR-3A** (Bandai)
page 75
British Motors made the first
TR-3s (A-Type) in 1957 and exported
the sportscar mainly to America.
The toy is remote controlled.

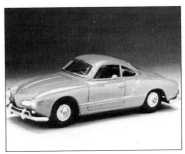

154. **1965 VW Karman-Ghia**
(Bandai) page 77
The "poor man's Porsche" or
"rich man's Beetle" was designed
by Ghia of Italy and manufactured
in West Germany by Karman. VW's
luxury coupe met with instant
success.

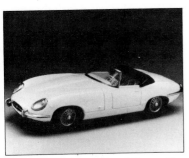

155. **Porsche 356B** (Kaname Sangyo)
page 77
Many car enthusiasts who dislike
Porsches rave about the 356. Built
from parts designed for the VW, the
Porsche motor sounded every bit as
noisy as the VW's. The 356 had four
style options: A,B, C and Speedstar.

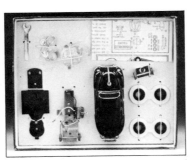

156. **Volkswagen Construction Kit**
(Masudaya) page 78
Compared to the number of tin-plate
toy cars that were on the market, the
number of construction kits was rare.
This one is for a battery-operated car
and came with instructions in English,
which would indicate it was made
for export.

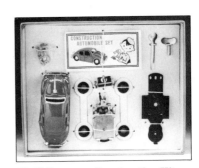

157. **Volkswagen Construction Kit**
(Masudaya) page 78
Another construction kit, this one
for a wind-up car. Choosing the VW
style of car for the kit was natural,
since the car already looked so toy-
like. This kit is all the rarer for
never having been used.

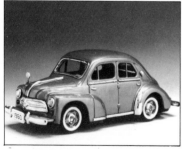

159. **Atom Car** (Yonezawa) page 80
The so-called "cigar-shaped" racing
car was an achievement of a bygone
era. The shape evolved from trial and
error, in attempts to build a faster and
more powerful racing car. This toy
shows the driver in full racing gear,
including helmet and goggles.

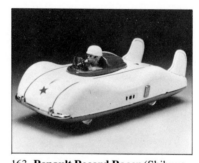

163. **Renault Record Racer** (Shibuya
Seisakusyo) page 82
The Renault is one example of the
understated styling of the fifties racing
car. That was before anyone thought
of adding rear spoilers, aerodynamic
wings and so on. The helmet on the
driver of the toy is typical of
the period.

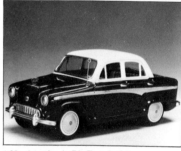

168. **Austin A-50 Cambridge
(Nissan)** (Kokyu-Shokai) page 84
During the fifties, four Japanese
auto makers formed separate agree-
ments with foreign makers in order to
gain advanced technology and im-
prove Japanese production methods.
A top-selling product of a Nissan-
Austin (Great Britain) partnership was
the Austin A-50 Cambridge.

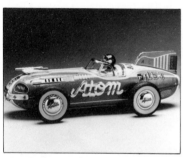

169. **1959 Renault 4CV (Hino)**
(Yonezawa) page 85
The genius of car design, Dr.
Porsche, created this car with an
air-cooled engine for Renault. One
account claims he was forced into
it by the French firm. In Japan
the Renault was manufactured
by Hino Motors.

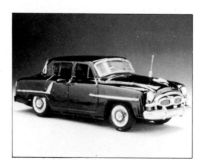

173. **1956 Toyopet Crown RS** (Asahi)
page 86
Crown is Toyota's luxury model and
its advertising slogan was, "Someday,
I'll own a Crown …" The first of this
line was introduced in 1955. It fea-
tured center-opening "French doors"
and a distinctive front grill.

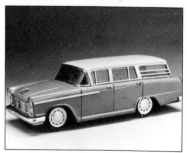

180. **Cedric Station Wagon** (Asahi)
page 88
Nissan stopped production of
the Austin in the mid-fifties and went
on to introduce the Cedric station
wagon. Cedric looked American and
became Nissan's quality line.

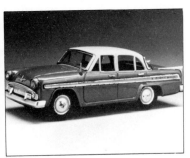

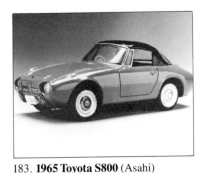

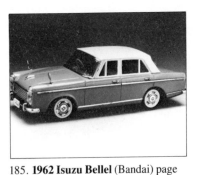

181. **1957 Prince Skyline DX** (Bandai) page 89
This was the first model of Nissan's well-known luxury line, the Skyline. Developed by Prince Motors, it out-classed all other domestic cars on the Japanese market at the time.

183. **1965 Toyota S800** (Asahi) page 90
Toyota created a sensation at the 1962 Auto Show with its sports car, the Publica Sport. The prototype's oval body shape was developed along principles of advanced aerodynamics. Capable of speeds up to 155 km/hr, the S800 became a popular racing car.

185. **1962 Isuzu Bellel** (Bandai) page 90
Heralded as a "guest room on wheels," the Bellel had one of the first diesel engines. And those early diesel engines were far noisier than today's.

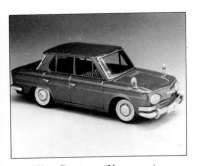

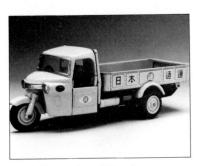

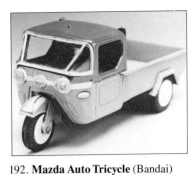

189. **Hino Contessa** (Yonezawa) page 91
Contessa was the principal model produced by the now-defunct Hino Motors. Like the Hino-built 1959 Renault, the Contessa also had a rear-mounted engine. As far as attrac-tiveness is concerned, the Contessa's style is ageless.

191. **Daihatsu Auto Tricycle** (Nomura) pages 92-93
Many people are around who remember Daihatsu's three-wheeled vehicles—not only trucks, but tanks and trailers too.

192. **Mazda Auto Tricycle** (Bandai) page 94
Everyone knows Mazda as the maker of the RX-7 and Familia, but not everyone realizes that it used to be as big as Daihatsu in the manufacture of three-wheeled cars and trucks. One of its standard models was copied in this toy. There used to be many other manufacturers of three-wheelers, but they're all gone now.

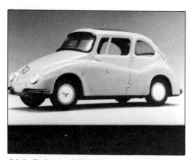

196. Daihatsu Midget (Yonezawa) page 96
Introduced in 1957, the Midget was an instant success in Japan, where small shops found it made the perfect delivery truck for maneuvering through narrow city streets. In 1959 the Midget cost about $511.

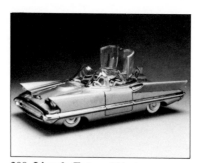

201. ToyoAce Truck (Asahi) page 98
This toy is a copy of Toyota's best-selling four wheeled truck. With only slight model changes (such as adding two more headlights), the ToyoAce remains a perennial favorite with wide appeal.

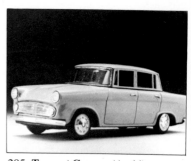

205. Toyopet Corona (Asahi) page 100
In 1960, the Corona underwent a complete style makeover into the model copied here. The result was a linear and stylish body design.

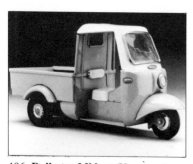

206. Subaru 360 (Bandai) page 101
The 360 was introduced in 1958 as the people's car of Japan. Nicknamed the Beetle because of its shape, this car became popular overnight— it still has ardent admirers.

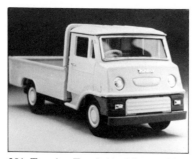

208. Lincoln Futura (Alps) pages 104-105
The Futura would look right at home in a science fiction movie, but it was an actual car created by Lincoln in 1955. It was expensive to own a Futura, but it was no ordinary car. It was the look of the future.

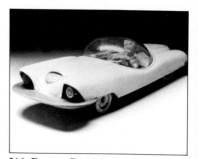

216. Dream Car (Line Mar) pages 110-111
Starting in the late fifties, American auto makers created cars with futuristic design and performance features. None of them was built for sales: each was meant to be the ultimate American dream car.

INDEX

B = Battery operated

S = Spring mechanism

F = Friction

Those Gorgeous American Cars of the Fifties

The fifties are back—the streets are filled with a fifties revival in clothes and hairstyles and even the big loud cars that were meant to disappear years ago. Young people who are wearing the fifties styles and fixing up those old cars of course have no way of knowing what it was like back then, but, in their own way, they have rediscovered part of the magic of the fifties.

For many of us, the fifties is a sentimental era, a time we remember as fraught with great hopes and dreams. It was also a time of transition. While people were filled with dreams and expectations, there was always an edge of uncertainty as to what the future would bring. We could only wonder how our lives and environment would be changed by progress and technology.

TV came into our lives in a big way during the fifties. And with it, in Japan, an insight to American culture. Shows like "77 Sunset Strip" and "Father Knows Best" were very popular, presenting to the Japanese a lifestyle that could only be described as fantastic—the big houses and big yards, the family outings in the car—it was a way of life that was totally out of reach in Japan at that time. All Americans were assumed to live a very comfortable and enviable life.

In the fifties one way to realize one's dreams was through cars. The same car that was on TV might pass you on the street, with its chrome glistening in the sunlight. All cars, especially the American cars, epitomized extravagance and luxury.

I remember them so vividly, it's no wonder that I've become fascinated with collecting toy cars. The nostalgia we feel for the toys is also a feeling for the past and the cars we knew. A car is really an integral part of our lives—a tool that helps us work and play. Each model also has its own design and styling that tells us something about the values and concerns of the time. We felt attached to our cars because they reminded us of all the experiences we had with them. In the 1950s, everyone dreamed about owning a car. And every kid wanted a model of his or her favorite car, a fact that wasn't lost on the toy manufacturers.

More than any other kind of tin-plate toy, cars were the most widely produced. Every kind of vehicle being driven in the 1950s became the model for a tin-plate toy.

Tin-plate toy cars of the fifties were very well made. Just to make a hood emblem then required making a separate mold, and it normally took a couple hundred molds to make one car. Today the parts are easily formed in plastic. If one tried to make a tin toy today, using the old methods, it would cost $80,000 just to make the molds, plus the cost of manual labor to connect the metal tabs and assemble the parts. The process would be nearly impossible today. They say that in the old days, the iron plate for toys was actually thicker than what was used for the real cars. The toy manufacturers never skimped on material or quality simply because they were making toys. It took this kind of dedication for the quality of Japanese toys to reach international standards.

My collection of tin-plate cars was launched by a man I hadn't known previously, Mr. Yamada. He had looked me up after reading a magazine article of mine about my collection. He had several dozen cars that had belonged to his son. He presented them to me, saying "they'll only get old lying around my house in boxes." Yamada had kept the cars in excellent condition.

Yamada is himself a collector and we've become friends through our common interest in collecting, although we collect different things. He comes to every one of my toy exhibitions and when we talk about toys, the difference in our ages vanishes.

I'm happy to see my collection growing, but it's even more gratifying to see more and more people become interested in toy collecting. Cartoonist Ryohei Nishigishi has dedicated most of his efforts to portraying the fifties. He would often include a three-wheeled auto or tin-plate toy in his drawings. One of my favorite artists, he treats toys with such warmth that I suspect they must hold a special place in his heart as well.

For people like Mr. Nishigishi and myself, the fifties have never gone away. ●